**TALKING GENDER:
CONVERSATIONS WITH KENYAN WOMEN WRITERS**

TALKING GENDER:
CONVERSATIONS WITH KENYAN WOMEN WRITERS

EDITED BY MIKE KURIA

First published in 2003
by PJ – Kenya
PO Box 69287
Nairobi

Copyright © 2003 Mike Kuria

ISBN 9966-803-06-X

All rights reserved
No part of this publication may be
reproduced or transmitted in any form
without permission

Typeset, printed and bound at Peepal Tree Press, Leeds, UK

ACKNOWLEDGEMENTS

First, much appreciation to the women authors for availing themselves for interviews and the courage to allow me to publish them. I would also like to thank Daystar University for providing research funds, The Yorkshire Arts for funding the publication and Jeremy Poynting and Hannah Bannister of Peepal Tree Press for technical advice and training. I would especially want to thank Hannah for help with the cover page, Natasha Marshall for help with typesetting, Emma Smith for kindly agreeing to proof read the manuscript for me, Manel Herat for not only reading the interviews in the early stages but also for assistance with the index and much encouragement. Thanks to Dr Jane Plastow for the wise counsel throughout the project. To my wife, Gillian, and my daughters, Ivy and Daisy, I could never be grateful enough for all the comfort and will to live that I draw from you. Thank you for being there even when others would have given up on me.

CONTENTS

Introduction	9
Wanjiku Mukabi Kabira	17
Marjorie Olughe Macgoye	51
Grace Ogot	71
Leah Muya	101
Margaret Ogola	123
Pat Ngurukie	151
Index	175

INTRODUCTION

While studying for my master of philosophy degree at Moi University, Prof K.E. Senanu from Ghana, who was taking us for an African literature course, introduced us to Tsitsi Dangarembga's provocative novel, *Nervous Conditions*. Needless to say we discoursed on the ways in which the novel challenges patriarchy as an institution. I loved and loathed the book at the same time. The narrative is brilliantly done. The plot is simple yet powerful. The perspective is that of innocence yet deeply insightful in its examination and exposure of the forces that combine to undermine African women's position in society. But I also felt, as a man, what I assume many women must have felt for generations in their encounter of female images in novels written by men: horribly misrepresented. I felt that men in this text are caricatured and universally treated as evil patriarchs bent on brutalising and oppressing women. The novel seemed to dichotomise otherwise complex issues into antagonism between men and women with men as aggressors and women as victims. There also appeared to be an African versus Western/European bad-good opposition respectively in the context of gender politics.

While I understood and empathised with the issues that Dangarembga was raising I could not help but feel there was something wrong about her project. I had grown up in a village where women were victims as well as aggressors. I had seen women who would not allow themselves to be taken for granted in the same manner that Babamukuru does to Maiguru in *Nervous Conditions*. I knew from experience that African women are not passive victims. They may be silent but not necessarily silenced. To be fair to Dangarembga she has one or two women characters breathing fire and brimstone in opposition to male autocracy but they are the exception rather than the rule. It might be argued that that indeed is the reality on the ground but I think there are more African women

ready to stand up for their rights than the book is willing to allow. In 1993 while teaching at Daystar University in Kenya an American colleague gave me Alice Walker's novel, *Possessing the Secret of Joy*, and asked me to read about women's genital mutilation. I could not help but see the similarities between the two books in their approach to gender issues in Africa. Walker's novel again accuses African men of victimising their women by mutilating the women's genitals. Again, though I was opposed to female circumcision I felt Walker was engaging in oversimplification of issues and polarising men and women in a way that was completely alien to my experience of Kenya. The male images I was seeing in both texts, though recognisable in society, were most definitely not the norm, as the two books seemed to purport. Increasingly I felt that I needed to do something that would examine the issues raised by the two books in the context of specific realities within specific communities. I felt that African scholars do not have to pander to male chauvinism in order to be critical of western theories of gender in Africa, which seem to limit themselves to inscribing women in terms of disability or being silenced and muted. It is also not necessary to swallow western theories hook, line and sinker, in order to be critical of male bigotry in Africa and her traditional institutions. There had to be a more sensible middle ground and I was convinced that African women writers had identified it but that few of us had been listening to their views. I wrote to Prof Senanu telling him that I wanted to do a Ph.D dissertation on feminism and African women's literature. Prof Senanu recommended that I read Florence Stratton's critical work *Contemporary African Literature and the Politics of Gender*. I was further intrigued by the mixed emotions that the book raised in me. I identified with Stratton's exposure of the ways in which African women writers' works of art had been sidelined by a male dominated literary criticism. But I also felt that her reading of the African women writers was too skewed in favour of western perceptions of gender. I felt even more persuaded that I needed to do more research in this field. In 1997 I began my Ph.D research at the University of Leeds in the U.K. under the supervision of Dr Jane Plastow. My thesis, *The Challenge of Feminism in Kenya: Towards an Afrocentric Worldview* was finally completed in 2001. In the course

of research for this project I came across Obioma Nnaemeka's writings, which seemed to answer many of the questions and misgivings I had begun to struggle with after reading Dangarembga, Walker and Stratton. Finally I had found a woman who spoke against sexism in Africa in a way that resonated with my own experience. Here was a woman critical of both racism in western theories as well as sexism in African systems, both modern and traditional. Obioma argues against simplistic binary oppositions when it comes to feminist issues in Africa. She argues against interpretations of African traditions such as polygamy out of their social and historical contexts. But she also presents a strong case for dismantling many institutions and ideologies that serve to limit African women's potential. Her interpretation and exposition of the differences between motherhood as experience and as an institution, in her introduction to *The Politics of M(O)thering*, is a case in point. Dr Plastow and I did not always agree but we both felt the need to let African women speak for themselves by interviewing them on the issues that I was raising in my dissertation. Due to limitations of time and money I decided to limit myself to Kenyan women writers. In a way this project is an expansion of Adeola James' book *In Their Own Voices: African Women Writers Talk*. But this book is much more limited in the sense that it only interviews Kenyan women writers. However, that also means it is much more focussed in terms of regional representation and subjects of discourse. It is also different because the writers interviewed do not appear in James' book and some of them, such as Grace Ogot, represent voices that James would have liked to include but could not due to circumstances beyond her control. I believe this project also marks the first time that Kenyan women have been brought together to discuss gender in Africa with specific reference to controversial subjects such as polygamy, wife inheritance, female circumcision (or female genital mutilation) amongst others. The following chapters are a result of my attempt to converse with a selected cross section of major Kenyan women writers in an attempt to hear them speak directly about their perceptions, interpretations and experience of gender issues in Kenya and Africa in general.

I did not pretend neutrality in the matters that I raised with the women but rather presented my arguments to them, sometimes taking the role of the devil's advocate by trying to sell to them what I considered to be male perspectives on the issues raised. By playing this role I hoped that the women would then articulate and defend the issues closest to their hearts. They did. I presented the same or similar questions to each of the women interviewed in order to see the variations of attitude and approach to gender politics by the different writers. The result is an expression of diversity that I believe is symptomatic of the reality on the ground in Kenya as well as in many parts of Africa. We have writers and activists such as Wanjiku Kabira who not only argue for embracing the term feminism but also view African men as mainly to blame for gender imbalance in Africa. Marjorie Oludhe Macgoye says she is not sympathetic to feminism and that the tragedy of the movement is that many feminists seem to go out of their way to emulate men rather than celebrate being women. Margaret Ogola argues that patriarchy is a necessity and that there is no such thing as a conspiracy between men against women. Ogot says that western women put too many stumbling blocks in the way of their men and that the relationship between men and women is that of friendship rather than antagonism. She however boldly declares such customary practices as wife inheritance and polygamy oppressive to women. Pat Ngurukie, in conformity to her religious convictions, argues that women should submit to their husbands and that equality is a myth that cannot be sustained even where only one sex is concerned. Leah Muya's contribution brings to the fore the complexity of female circumcision and the ways in which communities can be rallied against the practice without the animosity usually attendant to many foreign driven campaigns against the practice in most African communities where the ritual is practiced. These summaries really oversimplify the very complex and wide ranging ideas expressed by the specific women. Each of the writers has to be read in full in order for her ideas to be understood in perspective. In this collection of interviews, I believe, readers will find an expression of divergence on matters relating to women's development in Africa and also a good beginning point to cultivating harmony be-

tween men and women in the continent. The interviews reveal that African women are not too keen on imbibing western feminist values but they are passionate about their own freedom and equity in access to resources. They are not asking for tokenism and favouritism. They are simply asking for an enabling environment to flourish to their full potential. I hope the interviews will provide helpful insights for reading African women's literature in the context of the communities out of which and into which it is created. I believe that if the battle against sexism and discrimination against our women, African women and indeed all over the world, has to be won we must get men listening. These interviews were my way of listening to Kenyan women and in them I invite my fellow men to listen and understand that African women ask for no more than is theirs by right and that by supporting them to enjoy their full human rights and develop to their full potential we shall have done ourselves justice too!

WANJIKU KABIRA

WANJIKU KABIRA

INTRODUCTION

Wanjiku Mukabi Kabira is one of the leading gender activists in Kenya. Trained both in Kenya and abroad, Kabira is also founder member of Collaborative Centre for Gender and Development which has been very active in campaigning for affirmative action in Kenya. As the co-ordinator of the centre, the senior lecturer in the department of literature at the University of Nairobi helped bring together women working in the NGO sector under the umbrella of Women's Political Caucus to lobby for greater involvement in government. As a result Kabira was appointed one of the commissioners in the constitutional review team in 2001. She has written widely on issues affecting women, beginning with her dissertation titled *Images of Women in Gikuyu Oral Literature* in 1994, to various books and articles geared toward campaigning and or sensitising people to the plight of women in Kenya. She has co-edited/authored many books such as *The Road to Empowerment, Celebrating Women's Resistance, Towards Gender Responsive Politics, Our Mother's Footsteps, Reclaiming Women's Space in Politics, They Have Destroyed the Temple* and many others. Kabira argues that gender mainstreaming, with the engendering of such institutions as the national budget and economic policies, political policies, and constitutional matters is key to winning the struggle against women's marginalisation. Kabira has worked closely with international bodies such as SIDA, DANIDA, World Bank and UNHCR to train and equip gender activists working in Kenya. This interview was conducted on the 12th of September 1998 in the lobby of the Silver Spoon Hotel in Nairobi.

KURIA: As a person who has written widely on the Kenyan women's liberation movement in articles, anthologies and books edited by yourself as well as other people what would you say gender activism has achieved in Kenya so far?

WANJIKU: I think there are a number of things that can be listed. First you have to realise that the beginnings of the women's movement in this country was based on the initiatives of Maendeleo ya Wanawake, and here I am thinking outside tradition because we have a lot of information about what was happening in the traditions which in my view – and I have written about it in *Celebrating Women's Resistance*, I think you have seen the book – demonstrate how the women have tried to cope with their daily problems and so on. I am thinking of their daily reproductive roles in terms of looking after the children, fetching water and that kind of thing. In terms of organised activism, outside the clan and family organisations, I think Maendeleo claims some kind of concrete initiatives. Their activism, initially by whites, the wives of the settlers, dates as early as the '50s. I was at Maendeleo the other day, this office here,[1] and one of things that I could tell, and I have never been a member of Maendeleo, is that in the history of Maendeleo – and I only happened to be sitting in that office and saw Phoebe Asiyo 1960-1961, Jael Mbogo, Jane Kiano, and all those other heads of Maendeleo who are women still in leadership today such as honourable Kittony – there is evidence that the organisation has facilitated growth. You can tell that Maendeleo has facilitated women's leadership and that is why all those leaders of Maendeleo are national leaders now. A lot of them have either gone through parliament or tried to get to parliament at one time or another which means they have moved from the initial activities introduced by the white women of growing vegetables, making cakes, and so on. Such activities were really foreign to African women in the sense that the white women assumed that African women were also housewives while in fact they were not. They were and still are agriculturalists, they are involved in the economy and so on. So there is a sense in which you can argue that the fact that these women are still in

leadership positions today reflects on Maendeleo's contribution to women's development.

KURIA: Yes

WANJIKU: I think one can count the organisation's achievements. Take Jane Kiano for instance who has not gone to school but has made an impact in the women's movement. Look at Phoebe Asiyo who introduced a motion of affirmative action last year which made great strides, even though not passed, in the way in which it has really rallied the Kenyan women around the Kenya Women's Political Caucus. And by the way we at the Caucus have now decided that grassroots is not our business – we have been there long enough – the institutions must change, the policies must change, the ideology must change, the planning and programming of government programmes must also change. So there is a sense in which there are certain achievements of gender activism and Maendeleo can lay claim to them, and I am not a member of Maendeleo or a friend for that matter but I think one has to accept that the organisation has made valuable contributions. I also think that the struggle by Maendeleo for self-identity when there has been so many political manoeuvres to control the organisation is still a credit to some of the members of the organisation. Women's resistance and the efforts to manipulate the movement is clearly demonstrated through the marriages and divorces of Maendeleo to the ruling party.[2] The other thing is that although Maendeleo begun around what I am calling reproductive roles or house based roles, there have been many other organisations for instance FIDA (International Federation of Women Lawyers) that have come up to actually talk about women's rights. That is progress. We are talking about moving from welfare oriented activities to empowerment activities. We can also cite the struggles by the National Council of the Women of Kenya, although the council has also gone to the grassroots and is not networking as well as it should. I think there is some progress when talking about women's empowerment in the context of the struggles that have emerged and continue to be maintained. If you look at FAWE,

Forum for African Women Educationalists, there is a clear demonstration of the focus on education as a critical issue in terms of women's empowerment. Dr Gachukia, a founder member of FAWE, has actually been in the women's movement for a long time. And she has been recognised quite often by different stakeholders. As a senior educationist she has continued to promote the education of women and girls. Since I have been in the drafting committee for the constitution, I must admit that I have seen some progress. I think that for five out of twelve drafters of the constitution to be women is progress. Women were able to organise themselves to say, 'we cannot have three women and have seven men', and this was a group of about 25 women at a meeting of about 160 participants. For them to be able to argue their case and to make even the heads of political parties feel guilty and say, 'okay let us add two women even if it means we have a committee of twelve instead of ten', I think that is progress. And I think the current bill and the constitutional review is a clear demonstration of the progress that women are making. Have you read it?

KURIA: No, unfortunately no.

WANJIKU: You should be able to read it to see how affirmative action is consistent within the bill. Gender equity must be addressed, eight out of 25 commissioners must be women, one or two of the three secretaries to the commission must be a woman. If the chair is a man the vice must be a woman. There is a lot of progress in that area. But that is actually in terms of women's empowerment and taking women into the centre if you like. But then there is the other aspect of mainstreaming gender within the national development planning. This is where we deal with, among other things, changing the curriculum so that it is good both for boys and girls and therefore looking at gender responsive planning and programming. Gender is about democratising society, gender is about social transformation, gender is about improving the institutions, the philosophies and ideologies so that they open up and create space for both men and women. But gender is also about facilitating the development

of the potential for both men and women and therefore, apart from putting the women into the mainstream, thinking about how you influence the mainstream so that the it becomes democratic.

KURIA: And make it continue producing women whose potential is unlimited?

WANJIKU: Yes, but it is also so that it changes its own philosophies, it changes its own way of doing things, it changes its kind of ethics. I have been involved in that kind of process. For instance, we have been working on the national budget. Just looking at the national budget and saying, 'this is the cake, how much of it is going to the women?' We are arguing that because of the way women have been brought up the more resources that reach women the more resources reach the family. That is because their priorities, even at the family level, are different from those of the men. For instance, when a woman gets her salary she will think about food, she will think about household items. When a man gets money he might think about a plot of land.

KURIA: Or a car for that matter?

WANJIKU: Yes, so if you are thinking about human development, not economic development, the more the resources are accessible to the women the higher the likelihood of improving the livelihood of both men and women as well as the children.

KURIA: Right.

WANJIKU: That was a long answer.

KURIA: Yes but it was a good one. I was going to ask you about the women's movement any way. When I am reading about the women's movement, especially in Britain and America, it seems like there was a time when there was a mass movement. I am thinking of such movements as women campaigning for their right to vote and so on. Has that kind of thing ever happened in Kenya?

WANJIKU: Well... what is happening in Kenya right now... you might not know much about the Women's Political Caucus, and I am the convenor for that caucus...

KURIA: Then you are the right person to answer that question.

WANJIKU: When the Phoebe Asiyo motion was defeated, in May last year, I think it was, the women parliamentarians, leaders of NGOs and gender activists came together and said 'it is time we came together to ensure that the policies change, that we influence the way the country is going, and that we stop taking responsibilities for women's struggle and shift the responsibility to where it is supposed to be.' You see, if women are not educated, it is not the responsibility of the women. They have a government. We also pay taxes. So it is the business of government to ensure that this happens. I think it is amazing to see how within one year we have been able to influence the constitutional reform process. And by the way the constitutional structure that was adopted by everybody was developed by the 'Caucus'. I think it is the first time that women in NGOs have decided that there is nothing dirty about politics, it is only the men who are there who are dirty.

KURIA: Or the politicians there.

WANJIKU: We are saying the men because there are hardly any women in it. The struggle for gender equity has taken a momentum and I think that my anxieties, if I may say so, is how to maintain or ensure that it remains intact. There is a sense in which the women's movement has been gaining momentum. It has moved away from the welfare oriented activities, if you like, of the type that characterised Maendeleo in the early part, that is in the middle of this century, to more empowering activities. It has moved to collective bargaining which is what is happening now through the Women's Political Caucus. And we have Maendeleo in the Women's Political Caucus, we have Kenya Medical Women's Association, we have university women, we have widows and orphans, we have the League of Women Voters, we have FIDA

and so on. All the NGOs that call themselves women's NGOs are actually in the Women's Political Caucus. What we are trying to do is to ensure that we are talking about a network and caucusing around issues rather than establishing another NGO to co-ordinate activities. Up to now it has been working. In fact we are trying to ensure that it remains intact to again ensure that we get a good constitution and that we have an impact in the 2002 elections. There is a momentum and let me tell you, for the first time, I think, in the women's movement, I have met women at the supermarket who do not know me but probably have seen me in newspapers, or heard me over the radio or seen me on TV and they have told me, 'are you so and so' and I have said 'yes'. And they have said 'We are very happy with you. Know that we are all behind you'. And this has happened very many times at supermarkets with women that I do not know. I think it tells you that the movement is coming up.

KURIA: Oh I see.

WANJIKU: I read a statement from a Canadian author some years ago, so I do not remember her name, who said that every time a woman wakes up and realises that they have been discriminated on the basis of their sex, the women's movement is born in her. So I have seen it being born in very many ways.

KURIA: So would you feel comfortable saying that the women's movement in Kenya is not so much of an established system in a formal way – I know that if we trace it back to the old times we would still find women who were concerned with their less privileged position – but in terms of its being a well established movement in Kenya, is the movement something that is developing and gaining momentum but which has not been there in the real sense of the word?

WANJIKU: No. I have refused that before and many times. I have written an article with Philemina Oduor, in *Local Feminism and Global Perspectives* on the Kenyan women's movement...

KURIA: Now I have not seen that one, where is it?

WANJIKU: Check with the Ford Foundation. The book was published in New York so I only have one copy but I could get the article for you. Women's movement in this country, the grassroots women's movement, is the most powerful movement we have in the whole of the African region. The only thing that has happened is that there has not been a very clear connection between what we would call the NGOs movement and the women's grassroots movement. The women's movement has a membership of about three million! I do not know which male movement in Kenya that has as many members, even Moi did not get so many votes in the 1997 presidential elections you see. So in a sense the movement has been there but it has not been accorded its due recognition. For me, and you will find that in *Celebrating Women's Resistance*, women have been resisting oppression, they have joined together, they have bought land, what more movement are you looking for? They have subdivided land for themselves, they have acquired title deeds, they have thought about inheritance in terms of how do you give your piece of land to your son when you have bought it within the women's movement? This is at the grassroots level. So I have no idea which other movement women are looking for. My argument is that all those people who think that the Kenyan women's movement is disjointed are misreading history. They are misrepresenting history. All we need to see this misrepresentation is to look at the women's groups in this country in whatever activities they are engaged in. And that is why I gave you that quotation, that every day that a woman wakes up and realises that she is discriminated on the basis of her gender the women's movement is born in her.

KURIA: Yes

WANJIKU: So all those three million women who recognise that they need to get their own income, who recognise that they cannot inherit their land, who recognise that they have to join other women in order to be able to get land, those are part of the movement.

KURIA: Now, in Africa, let me not just say Kenya, but in Africa, many of the women writers, if you ask them whether they are feminists they will just say no. Perhaps that is stating it too flatly but the ones that I have seen asked, such as Buchi Emecheta and Ama Ata Aidoo, have flatly refused to embrace the term.

WANJIKU: What is feminism?

KURIA: Well that is a different matter altogether but I was going to ask you why it is that they refuse to take that term.

WANJIKU: I suspect it has to do with first of all a misconception of what feminism is all about. I think feminism is about humanism. Only that humanism is a male concept and in that context human beings have not been women until feminism came into existence. Secondly, it is because feminism has been associated with radical women's movement in the U.S. And those have not been our concerns. I think it has to do with the concept of feminism that African women are familiar with and specifically radical feminism. But also I think it's because the preoccupation of women in Africa could be different. Of course we are talking of local feminisms again. Depending on the issues and the interests of the community and the context, that is the cultural, the political and social context, there are certain issues which are priorities in Africa which may not be priorities in other places. I like the way Eddah Gachukia put it in 1984. She said that African women did not have any bras to throw away, you know, they were not wearing any. Even if they had wanted to throw them away they did not have any.

KURIA: I like that one!

WANJIKU: Basically it has to do with the misrepresentation of feminism and especially misinterpretation within our own region of what feminism is. I think that is why they say no. But if you wanted to get good information why would you ask such a question? I mean, if you really want to know whether they believe in feminism you do not have to ask them, 'do you believe in

feminism?', it is the issues they raise, it is their focus that can make you label them feminists!

KURIA: Actually that is the reason I am asking you this question. Because I read their books and see that the issues they are raising are perhaps the same issues that the feminists are raising, and yet they are saying that they do not want to be called feminists.

WANJIKU: Because feminism means throwing out your bra.

KURIA: Is there such a thing as African feminism?

WANJIKU: Of course it is there. I have to tell you this one which I got last year and thought was fantastic. I was doing some research in Embu. I was doing some evaluation for SIDA.³ I sat with these three women and about four men who were in a committee, a water committee or something. And we were talking about what the men had learnt from working with the women in the committee and what the women had learnt from working with the men, just to see whether gender relations were being influenced by this relationship. We ended up with the men talking about why they think the women are very good workers etc etc. And then this woman said that her grandmother, in 1964, the son had gone abroad and he came back. He must have been one of those flown out by the Mboyas. He came back and got married. In the house, he was looking after the baby while the woman was cooking. This woman, the mother of this man was saying, '*Hi ndagikua oriria atumia mahota arume. Kai Ngai utanginjokia muiritu*'.⁴ You see, 'how can I die now when women have won the battle'. I am sure she had not heard of American feminism. If you look at some of the statements from some of the women in *Celebrating Women's Resistance*, you discover that women have been struggling. I have a very good definition in *Our Mother's Footsteps* where this woman says: 'for me, what is freedom except to get this land which I have here. I can lie on it, I can walk on it, I can cultivate it but I can also give it to my sister'. That is what freedom is all about. So for her, freedom which as you know for the American woman of a certain class

may be to be free to marry — perhaps that is too basic — may be to be free to be a lesbian or not — as an African woman she is still dealing with the basics. Things like land, which means food, which means shelter and which also means some kind of a permanent place that you can call your own. So she may not be worried about her bra. It is just that the issues are different, in different times, different contexts and different historical periods.

KURIA: That brings me to the point where I would like to zero in on your stories. Your stories are very Kenyan in terms of cultural context.

WANJIKU: Actually they are from real stories.

KURIA: They are real stories?

WANJIKU: Yes

KURIA: That is even better. Were you thinking that the gender question needs to be approached from a cultural perspective when you were writing them?

WANJIKU: I do not know whether I thought about it analytically. I know that I cried when I wrote that story the...

KURIA: Which one? *My Co-wife My Sister?*

WANJIKU: Yes. Because actually I was remembering a true story of this woman, the mother of the children who is dead now, the one who gave a co-wife a daughter, yes that one actually died. Does she die in the story?

KURIA: No, she does not die in the story

WANJIKU: Okay. She died later and actually all her children were looked after by the co-wife. They are now adults. Yes, that is the story of a woman I met. I remember that she was a very good woman, the woman who did not have children. But the two women were also very good friends just like I said in the story. In writing it I was much more preoccupied with the idea

of the joy that comes with having a child. I do not even think that I was worried about how women are valued because of their productivity or fertility and so on. I was only telling of a human story where polygamy was not necessarily a hindrance. But I do not promote polygamy, that I would like to state outright.

KURIA: I was going to come to it but anyway…

WANJIKU: I do not support polygamy. But the story is not about polygamy but about the relationship between the wives. And the fact that they are not necessarily enemies. I thought that it is a beautiful story of two women who supported each other and who understood each other so much so that one of them actually gave the other one a child. I was thinking about the relationship. I hope somebody does not think that it is lesbian.

KURIA: No, no, it does not look like it at all. One of the things that caught my attention, although you say do not support polygamy – maybe we should deal with that issue just now – it looked to me that in that particular story rather than the women seeing the polygamous situation as an oppression, they used it to fight the dominant culture that decreed that your worth is defined/determined by your having a child. But they fought it within that particular system.

WANJIKU: Yes

KURIA: So I was thinking that polygamy is not such a heinous thing after all.

WANJIKU: Yes, but you know polygamy is in relationship to the husband who is not part of the story. Actually he is excluded. So he does not know why the wife is smiling. That is why I talked about our secret lives. You know what happens between the women and what kind of joys can be created from things that are happening around them but the men are totally unaware. You see you cannot have polygamy without the man becoming part of it. If the man became part of it then I would be promoting polygamy.

KURIA: While we are on polygamy, I do not support it either but perhaps for other reasons other than cultural or whether it can work or not, but it seems to me that the way polygamy was done in the traditional set up was better than now when men are polygamous unofficially. Then they were polygamous officially.

WANJIKU: Yes but that does not make it better it only makes the present worse.

KURIA: So that makes the earlier one better.

WANJIKU: No, the earlier one was bad, the present one is worse.

KURIA: Between the two evils, perhaps we should have the earlier one?

WANJIKU: No, you do not want either of the two evils.

KURIA: Anyway what is so evil about polygamy?

WANJIKU: I think one wants to first of all see the ideology behind it. We are actually talking about the status of man within that family and the status of woman within that family and the choices each one of them is allowed to make. We are also talking about human feelings. By the way in a lot of cases polygamy is for man. It is an institution to serve the interests of men. Basically that is the truth and the majority of the women would still prefer to have what you would call your own man. Not a man that you share with everybody. But it is also possible to argue that women again are recipients of that love. And you can decide how much of that love you are giving to each of the women. Therefore in terms of power relations the women are receivers again and the man has the power. I think it is a question of power and the status of men and women within that particular relationship. If we could have two men and two women and then all of you become polygamous...

KURIA: I do not want to over stretch this one but let me ask you one final question and then leave this whole idea of polygamy. In

many societies women are more than men, so given the ideal that all of them want to get married, of course that is not true, then polygamy would have to be there. Would it not be unfair to insist on monogamy and deny those women who want to get married a chance?

WANJIKU: I think that is a pedestrian argument. That is the one that is always given that women are 51% and men are 49% as if they are all getting married at the same time. Well I think maybe it is a complex process. But you know it is the permanency of marriage that will make that kind of situation arise. One may want to ask whether it is necessary to be married all your life and to the same person.

KURIA: I would not be polygamous myself but if three people agreed that they wanted get married, this man is willing to be married to these two women and these two women are willing to get married to this one man, if I were given the responsibility to convince them not to do that what reason would I give them?

WANJIKU: But that never arises. You see, that situation never arises. It is usually the man who gets married to this one and then falls in love with another one. It is never a situation of the three of us sitting together and saying lets get married.

KURIA: I was talking to Grace Ogot and she told me that among the Luos men do not just go out there to look for a second wife to get married to, they would be married to one woman who would tell them, 'I think you now need to get another woman'. The wife would even suggest the woman the husband should take as a second wife. Only then would that lady, chosen by the first wife, be approached and if she agreed there would be a marriage. That made me stop and say 'well it does seem that there was some agreement here'.

WANJIKU: But the question is why does she want another wife? Why does she want a co-wife? Maybe the burden. It is not a question of freedom. You see, this is a man who walks around with a stick the whole day and when he comes home he wants to sleep

with you and you have been working the whole day. So you may want to dump him to somebody else. But if the division of labour was different, if there was a close relationship, why would you want him to go to somebody else? So you want to understand the total context that creates that kind of a need for the women to say that they want a co-wife. It means that marriage is not meeting their needs. And that is why they want somebody else to come and take over from them so that they can be free. Even free from sexual intercourse where there is no love but meeting needs like animals. But any way this is not a very academic discussion because we are not basing it on any statistics.

KURIA: Many critics or people concerned with women's liberation in Africa will cite female circumcision, paying of dowry and polygamy as institutions that should go because they are oppressive to women, I was going to ask your position on this but I guess now I know except the dowry one.

WANJIKU: But you do not know about circumcision, did you ask me?

KURIA: No, I am afraid not yet.

WANJIKU: But you said you know my position...

KURIA: No, sorry, not on that one either.

WANJIKU: I want to go back to circumcision because of the reasons behind it. That is something we always ignore: that the idea behind circumcision is power. I think we all know that we are talking about the controlling of the reproductive roles of the woman; making sure that you reduce their sexual urge. It is tied together with cultural myths that are created to ensure that actually women endure the rite. These myths are created first of all to justify the argument that women cannot control their own feelings; that they are untrustworthy as many stories say, and that therefore you need to ensure that she has no desires. It is related to the control of her sexual life. It is also related to the kind of control... to the kind of pleasure she would experience. So in fact I think it is a criminal activity myself to

even imagine that you can continue with that kind of process. And then it is also related to the concept of ownership like the Somali kind of circumcision where you sew up the woman and then open when you come back. We talked about this in my class yesterday. We talked about other things as well as how can a ten year old girl be married to a 70 year old man like it has been happening among the Maasai. One of the young men said, 'but it is their culture'. The girls screamed. They said 'so what! let it go to hell'. And this young man said 'but you see the lady...' and I said, 'she is not a lady, she is a child!' I have no apologies to make over my position on female circumcision.

KURIA: What about dowry?

WANJIKU: Now dowry is a little different because one, it does not involve physical pain. Although it involves psychological pain. It is also a power relations game. You pay dowry and because you pay dowry you own that particular person. And no matter how you might want to see it otherwise, because something has been paid on your behalf there is a sense in which you feel obliged to stay within that home because you were exchanged for something, even if the man does not believe in it. Not many of us are like Field Marshal Muthoni who went and bought goats and took them back and bought back her freedom at the age of 60. There are not many of us like that. There is a sense in which it legitimises male power, legitimises male authority, legitimises the low status of woman within that community and it makes it more difficult for a woman to make a choice to leave. And of course the more money that is paid, the worse the situation for you. I remember this woman I was interviewing in Kirinyaga who said that if your husband did not pay the 90 goats then if he beats you, you could ask: 'how can you beat me as if you paid an elephant or a camel for my dowry'. For the men, it gives them that kind of power, promotes their ego and sometimes also encourages their male dominance which leads to violence within their homesteads. It is like I have bought you. *Wi wakwa wa Mburi.*[5]

KURIA: So you are part of my property?

WANJIKU: Yes. It is part of the bonding. But that is also related to many other things. Even moving from your own home to your husband's home. I was telling my students the other day that when you are a girl *wi mwihitukiri*,[6] you are on your way all the time. You are being prepared to go. When you get to a marriageable age *Ugetwo mundu muka*,[7] you are a newcomer. Your children belong to your husband's clan and you bring your girls up preparing them to be on their way. You have no roots even where you get married. You have no clan, you have nothing, you cannot inherit the land, your existence depends on your son and you are at the mercy of your own sons and so on, so you have nothing. *Guturia atumia na heho*.[8] When you are in your mother's home you are always being prepared to go and when you go to the other place of your marriage you are a visitor and you prepare your girls to move on to become visitors in another place. It is a vicious cycle.

KURIA: Yes, that is what makes me admire your stories, *My Co-Wife My Sister* and *I Cannot Sign*. It brings back the whole issue all over again. There are structures that are in place in society and to undo them you need to understand them.

WANJIKU: Yes.

KURIA: It seems to me that your stories can be read as the stories of a person who knows the situation, I think, and I could have been reading my own stories, but who seem to think that these institutions can be turned around from oppressive institutions to empowering ones. That is why I was asking you whether you think there is a need to indigenise the feminist movement.

WANJIKU: I do not think there is a need to indigenise feminism. I think there is need to bring the African experience into the feminist world and influence the feminist world. What I am saying is that indigenous African feminism already exists. The question should be: 'have we been able to tap it?' You see, in my view, although I am not analysing it, as I told you I wrote

that story at one sitting and I never repeated it, *My Co-Wife My Sister*, this is an institution within which these two women are and whose value depends on the birth of children. That is what I thought the story was saying. One of the women who has been blessed with those children and has the status within that family recognises the need of the other woman and therefore goes ahead to give her co-wife a child. Within the Gikuyu culture, if a man was barren the other men would organise for someone to come and father the children and it would be kept secret. What has happened in this story is what is not done within the tradition. The two women have coped with the situation that would be detrimental to the other woman. So it is the unity of the two women that is the focus and not the value of the institution.

KURIA: Yes that is what I liked. It is true that they have done what is not normally done and by the end of the day she is happy and smiling all the time. And the husband is wondering why is she so happy? The truth of the matter is that she has overcome in one way or the other.

WANJIKU: Yes, but she has also, now I am analysing my own story, I am just thinking that on second thoughts she has become human within an institution that considers her inhuman because she has no child. In the end her humanity has been assisted by the wife and not the society and not the husband. So it is the unity of purpose of the two women and recognition of the feelings that was at the centre of the story. If it promoted polygamy it was by default.

KURIA: Yes.

WANJIKU: *I Cannot Sign* is also a true story. It is also a recognition of the power of motherhood. These was a group of men who were trying to say that the cause (the struggle for Kenya's independence) is more important and that you should be prepared to sign so that we should go and kill a co-wife. But her motherhood or her role as a mother prevents her from signing her co-wife's

death warrant. By the way this is exactly the opposite of what happens in traditional stories. Most stepmothers are very cruel. The cruel stepmother motif. But in this story a stepmother sides with her co-wife. Remember that traditional stories are not only negative to the co-wives but also very negative toward wives as a whole: wives are irresponsible, unfaithful, they are senseless and often they are stupid and lazy. If you look at many of the Gikuyu stories, as they say, mother is god number two, mother is gold. But the co-wife and the stepmother are usually quite negatively portrayed. But this story presents a situation where the feelings of motherhood become more important than the cause itself. And now that I am thinking about it, I have not thought about it before, it makes sense. I have been arguing why it is important to put women in decision making situations, and one of the arguments we have been pursuing is how differently women look at the world. We are not saying that one is bad or that one is good. The struggle is good but the lives of the children are also good. If you have women in leadership postitions the priorities of the nation will change. They will think about food, they will think about security, they will think about the protection of children before they think about defeating Uganda if they are going to be at war. But the men will think about defeating Uganda and then say 'we have created some problems. We now have children refugees' afterwards. But the mother will think about where will the children be. So it is a question of bringing the two visions together to have a comprehensive vision. And I think that is what is lacking in our leadership. It seems they are good stories. I had not thought about it.

KURIA: I agree, they are loveable. And this brings me to the issue of marriage, family and motherhood. You have already dealt with motherhood. When reading western feminism one notices a feeling that these are generally oppressive institutions. I wonder what you think about that?

WANJIKU: Okay, I will go back to motherhood in case I have misrepresented myself. Motherhood, in terms of the relationship between mother and children, is not a competitive role, it is a role

of nurturing, it is a role that is supportive, it is a role that is educative. That is why many men look for mothers in their wives.

KURIA: I have heard that said before. I am not sure whether I believe it.

WANJIKU: You see what happens is that the mother makes sacrifices, the mother gives, the mother nurtures, the mother provides, the mother supports. So the children are recipients. But when it comes to relationships between wives and husbands it is a competitive relationship. You know, 'I am not your mother', as the saying goes so I do not have to nurture you, I do not have to protect or feed you, but the relationship between men and women is one of power. And therefore you find more struggles within the family between husbands and wives because of that competitive relationship. This is because the husbands are looking at the wives as people who should play the role of the mother and the women are always resisting that kind of a relationship, because we are not your mothers.

KURIA: Let me get this one clear here, they are resisting being mothers to their husbands but not resisting being mothers to their children.

WANJIKU: Yes, exactly. They are always fighting with their husbands because of the concept of woman and the status it bestows on women in society impacts at the family level. The woman is not supposed to be the head, but she gets into a relationship where she feels we are two equals. You are doing this and I am doing this. So there is a sense in which women are looking for partnership but the men are looking for supporters like the mothers. But also it is a conflict of the way socialisation has taken place. Where you are training this boy to be like you, this woman is also training this boy to be aggressive, to get women to do things for him, including the girls who are washing the clothes for him, who are cooking for him and so on. The relationship between the brother and the sister is also one of service. He is developing, growing, looking for a career, and looking for a time

when he can build his own homestead. But the girl is looking for something else. Someone else is looking for a homestead. So the girl is supporting the brother. When the brother goes away and he has been brought up to be looked after by women, his mother and sister, he cannot change all of a sudden when he gets another woman in the house who is now called a wife but who is now nursing children and expecting partnership at this level. This is where you have conflict. This is why, for instance, my thesis is about images of women in oral literature. I have talked about how the relationship between wives and husbands is actually equivalent to the relationship between women and men in society. But the one for the mother and their children is a different relationship. The one for fathers and their daughters is different and brothers and sisters to a certain extent also inhabit different relationships.

KURIA: Yes.

WANJIKU: What I was saying is that the socialisation process does not promote partnership between men and women. You are coming from a home where you have been brought up to be a man and to look down on women. When you come to this woman, in marriage, you have that attitude. The woman has also been brought up knowing that her status is low but she resents being in that low position. In fact I think that the women's struggle is most intensely highlighted in husband and wife relationships. That is why you find that many men who oppose women's liberation are not thinking about their daughters but about their wives.

KURIA: They do not want their daughters oppressed?

WANJIKU: No, they do not want their daughters oppressed. The concept of woman and the concept of wife are synonymous. I think this is why at a society level we always have to talk about a mother or a daughter if we want to get anywhere with men. That is because men do not see those two as a threat. A daughter does not threaten you, a mother does not threaten you.

KURIA: There is a whole range of complexities here that I have been thinking about. One, that men who have been so powerfully influenced by their mothers that they want to look for them in their wives should at the same time oppress that same image.

WANJIKU: In their wives?

KURIA: If my wife is the image of my mother and my mother is someone I love because of what she did for me why should I then I want to oppress my wife?

WANJIKU: Because she does not fit in that image. You see, if your wife spends all her life looking after you then you have more quarrels. What we are basically saying is that wives quarrel because they question. Because they also have a mind. Because they are also looking for things they want to do for their children and expect you to be the supportive husband. In a sense the struggle to become a mother to these children, to be able to invest in them, puts you on a collision course with your husband who is now looking at you as his mother to feed him, look after him, nurture him, support him in his career and so on. As they say a woman is one being that men love and hate. Because you are the mother, the wife and the sister in the same person. As you say it is a very complex relationship.

KURIA: Yes. It does seem so to me. I have seen your writings and somebody like Alice Walker who say they are in search of their mother's gardens. It means that in their mothers is a revolutionary spirit. There is someone resisting oppression and you admire that and therefore she is someone you are emulating.

WANJIKU: Now that you say it I have never thought about it. I have never thought whether men and women have the same image of the mother.

KURIA: It is interesting, isn't it?

WANJIKU: This book that we put together, *Our Mother's Footsteps*, like in the *Search of our Mother's Garden* we were thinking about

the one who has given birth to you and who has struggled to bring you where you are, not necessarily supported you. I suppose that Toni Morrison and Alice Walker are thinking the same thing. You are talking about yourself as someone who is struggling, you know, for liberation, both self and the liberation of women in general. And you are saying 'I am not the first one'. You see, we do not have wives as women. So we are building on our mothers and our mothers are older than our sisters. The concept of a mother is related to history rather than from the concept of the mother from a male perspective which is that of mother as the nurturer. We are seeing ourselves along a history where our mothers, not our wives since we do not have any, and our sisters are our agemates, have struggled to achieve what we have and where we have to continue the struggle for our daughters. So it is a historical image.

KURIA: Yes, and that same mother who was nurturing is the same mother in whom lay a revolutionary spirit?

WANJIKU: Yes that is what I am saying. It may not even be a revolutionary spirit. It may be the spirit of resistance.

KURIA: Agreed. I am just using different words to represent the same thing.

WANJIKU: Or even survival. I like watching *Roots*. Because *Roots* gives you the different ways by which people survive. This is why when people say there is no women's movement, I say it is trash. When you look at *Roots*, you can see for instance how Kunta Kinte's mother resisted slavery till the time she died although there was no aggression. The grand daughter of Kunta Kinte also resisted in a very aggressive manner. Even when she is raped she decides 'I am not raped'. She does not give in to the pain. She says, 'I am not raped. He has only taken my body. He has not taken my spirit', you know, 'my soul'. Her son, Chicken George, the way he resists is by wearing a mask where he is always smiling and behaves like he has no problem and will sing whatever song but inside, his heart is bleeding. Tom, who

is Chicken George's son, is a warrior. He fights directly and dies in the war. So I keep saying that the women's struggle has been like that. There are those who have contributed to the movement by collectively coming together and by saying 'we are going to help this one because she has given birth and she cannot go to fetch water. She cannot fetch for herself', and they are able to do that. There are those who have collectively come together to buy a piece of land which is theirs and therefore have broken tradition, and we have not given credit to these women. There are those who have come together to buy basic things at a household level. But it means that although I am a woman and I do not have anything else, I can still have what I need. There are those who have moved, like International Federation of Women Lawyers for instance, to aggressively lobby for women's rights. I think all these struggles, including the individual struggles like that of Field Marshal Muthoni who decided, after the husband married their house girl whom Muthoni was actually paying to look after him because she was busy collecting elephant tusks for sale, to find out how many goats were paid in dowry, bought the goats and took them back to buy her own freedom. All these individual struggles must be seen as part and parcel of the women's movement. That has influenced me and I am sure I am going to influence somebody else as well. How did we move into this one?

KURIA: It must be something you said along the way. Actually you were trying to show how the movement is deeply rooted...

WANJIKU: Yes, I think it is deeply rooted among the women of Kenya. I think there have been a lot of struggles. Unfortunately, because of our economic struggles and other struggles, a lot of it has not been recorded. We have not been able to harness the movement but it is there. I have an aunt whom I have been interviewing many times who is now about 75 and I remember interviewing her around 1984 about what she thinks is the status of women in the society. She was very articulate about the issues, like very many rural women are. I believe that this fight against what you call elite women who are supposed to be promoting liberalism

or radical feminism or whatever is actually a power game with elite men and political leaders. I believe that the women at the grassroots are, in most of the cases I can say, a 100% together. No woman wants to be beaten. No woman wants to suffer pain just because she is a woman. No woman wants to sleep out in the cold because she is a woman.

KURIA: Let me take you to the issue of female circumcision again. In my reading I have come across about four different kinds all of which are awful in my opinion. I have a number of concerns. First, is there any society, as far as you know, where men carried out circumcision on women?

WANJIKU: I actually do not know of any. I have not studied widely on that one.

KURIA: All the societies that I have read about it is women who actually do it on women. Here is my second concern, if I went through such a horrifying thing why would I do it or have it done on my daughter?

WANJIKU: Because you are living in a man's world.

KURIA: And it has affected me that much?

WANJIKU: You are living in a man's world and you do not have a place in it. You have a very small place and you try to even make sure that there is a place for your daughter. You would rather she goes through the sufferings and is accepted in that society because alone you cannot fight that battle. Alone you cannot actually create another society for your daughter. So you do it? You know, so that your daughter can be accepted in the same society. We are talking about a whole social structure. I know about this Member of Parliament, Somali, who was taking his daughter for circumcision just this last month.

KURIA: Just this last month?

WANJIKU: Yes. The daughter is ten. His argument was that 'my children are still living at home and they are part and parcel of that

community. Where would I take her if she is not circumcised. She is an outcast' and so on and so forth. It is still the same argument that even women use and I think there is a whole set of social mythology created about a good wife and so on. Social mythology is of course based on myth. And myths do not deal with facts but with emotions, beliefs. So when you are talking about a myth that a good woman can only be like this, a good woman should be circumcised because it will control her sexual urge and so on, when you are dealing with that kind of emotion as a woman you may not want your daughter to suffer from the same society but you also believe in it. You believe that she is going to be better, that she is going to be trained, that it is for her good, that she will become a good mother and nothing will happen to her. It is happening even today! I was talking to Dr Gachukia and she was telling me that last week they were in Kuria and Kisii where a lot of women cannot understand why you are fighting female circumcision. You see your worldview revolves around your own community. That is where you fit. And remember woman is a stranger like we said. Even your own home where you are married is not your home. You are always on your way. Now you are preparing this girl to be on her way to another home where at least she might have other children, preferably boys, who are now going to legitimise her position. At least she will not be thrown away although she may not own anything. So I think we are talking about a total social fabric that the woman is fitting into and trying to survive in her community. In spite of the fact that she may not want to think about the pain that her daughter will go through, she also wants her daughter to be accepted in the community.

KURIA: I am sure you are aware of the programme by Maendeleo in Meru and other parts of the country where they are trying to have the same rituals of circumcision minus the physical act. What do you think of that?

WANJIKU: I think it is a good approach. At least you are fighting one aspect of evil, the pain, the health related issues and so on. You have not fought the power struggle within it. But you are also

on the path of fighting the power struggle because the community will eventually see that the cutting itself or rather the lack of it may not make the women to be bad women or any less of women. But then what one may want to do in terms of the kind of education they are giving is to ensure that they destroy the myth through the kind of education they are giving. Education must introduce a new ideological base or orientation so that they do not begin training the children to do the things they were told to do when they were circumcised. I think it is a good step but we want to look at the curriculum.

KURIA: I know that at the beginning you said that circumcision is just criminal. But do you not think that to outlaw the practice might not do much because the worldview or the social fabric, to use your words, has not been changed? I think that is where Maendeleo becomes effective because they are working on the worldview of the people.

WANJIKU: We should do both. I think we need policies that are proactive in terms of dealing with women's issues. I do not believe that we are like animals who have to wait for evolution. I do not believe that we should wait for things to take their own course. I believe that as leaders we should have policies and by the way if you have policies that deal with circumcision, such as what we have been saying about structural adjustments, we may want a policy that also says something about how you cushion those policies. You want to think about this as a policy but even as you disseminate the policy you also talk about all those other things. Let the people know that this is criminal. Let the girls know that it is their right not to be circumcised. Let the mothers know that it is unhealthy, the two should go together so that the policy actually supports it. This would make sure that the people who go to do what Maendeleo is doing are not thrown out as people who have been influenced by American feminism and such kind of things. Personally I think that we need the two. One of the things that I have been saying is that we need to fight the idea that it is the women's responsibility to change all these issues.

KURIA: I agree with you there.

WANJIKU: The other day I was at giving a lecture to some lawyers, ICJ (International Commission of Jurists). These young lawyers were asking me, 'why aren't the women at the grassroots to go and teach those women because we know they are oppressed and so on'. I told them, 'there is nothing at the grassroots. The money is at the treasury and the power is in parliament. So what business do I have at the grassroots being poor with the women down there'. You want to make sure that this parliament recognises that it has a responsibility to impact on positive changes to promote women's struggle and empowerment. You want the budget, as it is calculated, to take women's agenda on board. I mean women have been at the grassroots for ever. Let Maendeleo be at the grassroots, I am not going to the grassroots. By the way sending the women to the grassroots is a way of diverting the issues. It is a way of ensuring that nothing is happening and then they give you peanuts you know, to go the grassroots while they are spending a lot of money to go to Mbagathi themselves. Why don't they go to Turkana to think about economic reforms?

KURIA: I believe we should be everywhere. I keep on coming to your word, the social fabric. I think the whole systems needs to be sensitised.

WANJIKU: I am not saying that nobody should go the grassroots. We have very many women who are happy to go the grassroots but I also know that the impact they are having is very little. Even if you go to Meru you are not going to the whole of the province. Sometimes you are only talking to 30 women. But you have the administrative personnel. In every village there is a chief, there is a DO. There is actually somebody who has the authority to make certain changes. If the government believed in it, they would not be asking Maendeleo. They would be calling upon the chiefs and telling them: 'this is what is happening to the children. It is your responsibility to ensure that you talk to those women and to those men as well and tell them, "this is a

government policy, the government has done this because they have discovered that these girls have problems with having children, these girls need to go to school, these girls need to do this and that".' Why do we have to have Maendeleo going to one village if you do not have national policies? Look at the changes that have taken place in other African countries. 18% of parliamentarians in Uganda are women. It has to do with affirmative action which is good leadership. We have never got beyond 0.3% or something like that in this country because we have bad government policy.[9] I listened to Moi the other day. He was talking to people in Machakos. And he says '*lakini hata nyinyi wazee, mwache watoto waende shuleni*'.[10] They laughed. You could see the lack of seriousness in the statement. If it was serious, if he actually believed in the statement they would have stood up and bowed to say 'we agree'. But they laughed because they could see the lack of seriousness in that kind of process. We are talking about policies, sectoral policies where women's issues are taken on board rather than always telling the women to change the situations for themselves as if they are the creators of the situation in the first place. I am not saying women should not go to the grassroots.

KURIA: Finally, all your works seem very conscious of the women's position. Was that something that happened gradually or did you make a decision at one particular time?

WANJIKU: I do not know what happened. I suppose your consciousness develops. In 1984, which is actually the same time I published the oral artist, I did a research in Kiambu with Dr Wangui Njau the sociologist. The research was based on women's contribution to economic development. I interviewed both men and women in Kiambu district. That research was an eye opener. Just by coincidence. I was not thinking about the comparisons. I was not thinking about a gender analysis. I was going to the women alone but then I thought 'it is a good idea to hear what the men are saying'. I do not think I have ever enjoyed a research like I enjoyed that one. We were talking about issues of land control, access to resource, women's perception of themselves and what

their contributions are and so on. It was a very good eye opener and I do not think I have ever gone back. And also listening to the men, you know, it was very good since it was also in Gikuyu, I would ask the women what they thought the men did. They would just tell you 'nothing'. You know, *'Arume ri ni mari kawei*,[11] you know, they are stupid. They keep thinking that they are doing things even when they are doing nothing. Then I would go to the shopping centre and sometimes I would sit with the men the whole day and ask them, *mureka atia barabara*,[12] the whole day'. And they would say 'when we are here we can hear what is happening'. We would go back to the women and tell them that they say they are busy because they hear things. For instance now they heard that we were coming and they were able to air their views. The women would ask, '*maigua meke atia*'.[13] We would say '*nimekuigua kundu kwi migunda*',[14] that kind of a thing. Then the women would ask '*maigua meke aitia na matiri mbeca*'.[15] So just looking at the two worldviews of the women and the men I thought it was very interesting. But then the more you discussed with the men or rather the more we discussed with the men the more we realised the kind of frustrations that they faced in not being able to be men, as the heads of their families. You have no resources, you have no land, no money, you actually cannot be a man except being the male. And they would tell you that it is very frustrating to actually be in the house when you are being asked to contribute something and you do not have. To fight that struggle you move away and wake up every day and leave as if you are going to work.

KURIA: But you are actually running away.

WANJIKU: And then they would tell you, 'now we have been here with you the whole day, except the tea that you bought us, we haven't had anything else'. So in a sense I kind of learnt how the socialisation process is also hostile to the men. The society has certain expectations of you but the society has stopped providing the resources to enable you to become the man that they expect you to be. So you lead a fake life. The process of alienation is

very strong where men are concerned. Even when they are talking to you at a superficial level and they tell you that we are here so that we can get exposed they know that at a deeper level they are suffering because they cannot fulfil their roles as men within that society. I thought that it was a very interesting dynamic and I think maybe this is why I pursued gender issues with a passion because I am a missionary in these things.

KURIA: Yes, you are indeed a missionary.

WANJIKU: Because the socialisation process is not good for men either. We are talking about a man for instance who is not allowed to cry in public but he has feelings. And you are telling him to kind of hold on to those feelings and not be able to express them.

KURIA: Thank you Dr Kabira. It has been a pleasure talking to you.

NOTES

[1] We held this interview in a hotel next door to the headquarters of Maendeleo ya Wanawake offices
[2] Maendeleo has been associated with the ruling party – Kanu
[3] Swedish Agency for Development Cooperation
[4] Kikuyu for 'oh, that I should die just when women have defeated men. God I wish you would make me a young girl again.'
[5] Kikuyu for 'you are mine in exchange for goats'
[6] Kikuyu for 'you are a passer-by'
[7] Kikuyu for 'you are called one who came' suggesting a foreigner
[8] Kikuyu for 'Keeping women in fear/ the cold'
[9] Since the interview, new general elections have taken place in Kenya. On the 27th of December 2002 nine women were elected to parliament and seven were nominated, making a total of sixteen out of a house of a hundred and thirty two. This represents slightly less than seven percent.
[10] Kiswahili for 'And you old men let the children go to school'
[11] Kikuyu 'men are have a problem'
[12] Kikuyu 'what are you doing by the road'

[13] Kikuyu 'After they hear when can they do?'
[14] Kikuyu 'They will hear of places where land is available'
[15] Kikuyu 'what can they do even if they heard and they have no money'

MARJORIE OLUDHE MACGOYE

MARJORIE OLUDHE MACGOYE

MARJORIE OLUDHE MACGOYE

INTRODUCTION

Marjorie Oludhe Macgoye was born in Southampton, England, in 1928 and educated at Eastleigh County High School and the University of London, receiving a B.A. in English in 1948 and an M.A. (part-time) in 1953. She worked in the book trade and in 1954 was sent as a missionary to Kenya, working in the CMS Bookshop, Nairobi. In 1960 she married D.G.W. Oludhe Macgoye, a medical worker, who died in 1990. She has four children and six grandchildren. She has worked as a bookseller, publisher's representative and editor, and has published six novels, a novella, two children's books, a history book, a book on Christian morals and two volumes of poetry as well as periodical pieces. Quoting Galatians chapter 3 and verse 28 she says that as a Christian she has always known, from childhood, 'There is neither Jew nor Greek, there is neither bond nor free, there neither male nor female: for ye are all one in Christ Jesus'. Macgoye has not only become a citizen of Kenya but has also become so integrated in her husband's Luo community, having learnt its language and culture, that she rightly considers herself Luo. All her fiction is set in Kenya, with Kenyan characters, dealing with Kenyan problems from the perspective of Kenyan cultures. They express a Kenyan consciousness. All her creative works explore Kenyan themes such as the struggle against colonialism, political murders such as those of J.M. Kariuki and Tom Mboya who were killed during Kenyatta's reign, post-colonial disillusionment and the search for nationhood. These themes are explicated from the point of view of African protagonists with the exception of *Homing In* and to a certain extent *Murder in Majengo*. Even in these novels, the white protagonists in my opinion have cultivated enough cultural literacy of the indigenous communities to warrant their views being considered Afrocentric. Macgoye demonstrates knowledge of African systems of thought in

her choice of Luo words and sayings as well as in employing Luo cultural themes in her novels. She constantly makes reference to Luo cultural practices, taboos and proverbs in much the same way Achebe does in reference to the Ibo of Nigeria. In *Victoria*, for example, Victoria cannot spend a night in her daughter's house as Luo mothers cannot sleep under the same roof with a son-in-law. In her latest novel, *Chira*, she uses a Luo mythology about a wasting disease that strikes people who defile themselves by engaging in forbidden practises, such as sexual liaisons with relatives, to explore the ravaging effects of AIDS among the Luo of Kenya. She is a true daughter of the soil as many Kenyans would say. This interview was held at Macgoye's house, Pangani, Nairobi, on the 24th of August 1998.

KURIA: Maybe we should begin with an issue that you raised over the phone when I first called you. I think I told you that I am doing research on African women's literature and you told me that you would rather that this classification were not there and that you would rather be judged on what is on paper.

MARJORIE: Yes, it just seems to me that it is not a category. Women's writing is not a category, women's Mathematics is not a category, women's medicine as distinct from gynaecology is not a category.

KURIA: Oh I see, but what about if that classification is to signify written by women. Would you rather not have that one as well?

MARJORIE: It seems to me that this is imposing non-literary criteria.

KURIA: That caught my attention because the category is what I am looking at...

MARJORIE: Ya. So you are going to define the category and persuade me that it exists, eh.

KURIA: Yes. But I am otherwise okay as far as you are saying that it should not be that because it is women who are writing then the writing is different. Is that the idea?

MARJORIE: Ya. That is my idea. And you will find that if you are asked to submit poems, or perhaps not to submit but to examine poems that have been selected for Heinemann, for instance, you will find that the poems selected are about women. Now if somebody asks you to submit poems, they do not have to be poems about men. And a good number of men's poems are about women. So, I just do not see that I am not able, as a woman, to address any area of discourse that I happen to know about. Probably I know more about women than about men, and less about men than other women, but all the same I do not think that this women/men's writing is a fair distinction.

KURIA: I think you have lived in Kenya for a longer time than I since you came here before I was born.

MARJORIE: I came here in 1954.

KURIA: Aha. That is a long time. I wanted to ask you a very straightforward question. Do you consider yourself a Kenyan, a Kenyan Briton, a Luo or how do you define yourself?

MARJORIE: I consider myself a Kenyan. Obviously my British heritage, like any other natural heritage is still there. And when you get older, you may find that some of your early pre-occupations come back. You know, you have rebelled against them. You have made a different kind of life. But come back to seeing well, maybe that was not so stupid after all. In those days I rebelled against some things within a community as far as it was a community. I certainly do not see myself as a Kenyan white, I mean I do not think that there is a community of Kenyan whites although there are a few people, not necessarily citizens, who make an agglomeration but they do not actually make community. So, yes, I see myself as a Kenyan and the sub-category is bound to be Luo.

KURIA: So when you are writing, and I have looked at most of your works, *The Present Moment, Victoria* and *Murder in Majengo*, for instance, all of them are set in Kenya and that is fine, but here is my question, do you write from a Kenyan perspective now that you consider yourself Kenyan...

MARJORIE: Ya, I have no alternative. I would be inept in writing about modern Europe because I have seen very very little of it. Let me just make one qualifier there; that does not mean to say that I may not write about it if I choose to and if I do my homework. And perhaps that is one problem with African writers as distinct from Caribbean writers. We are always being pushed to restrict ourselves to cultures. It is only perhaps Meja Mwangi, I think, who has adequately, although perhaps not at great depth, but he has dealt with other matters. One may write about anything so long as he or she gathers material about his subject.

KURIA: That brings me to the next point. Your book, *The Story of Kenya: A Nation in the Making,* unlike your other writings is not a work of art. What inspired that book?

MARJORIE: No. This was not inspired. This was a piece of work, an assignment that I was given. And of course a lot of it is now very out of date. But because I had to do a lot of reading this became very helpful to me in my writing the next book, *The Present Moment. The Present Moment* was a lot less painful birth than most of the others because I had already done research for *The Story of Kenya.* That was definitely an assignment.

KURIA: Well...even though it was an assignment, you expressed ideas that are still important, especially in the light of what is happening now in Kenya. You argued, for example, that the kind of Kenya that we would have was dependent on what we made of it ourselves.

MARJORIE: Ya, I mean even in an assignment you cannot deny your deepest beliefs.

KURIA: Do you think that the concept of Kenya is still a viable project?

MARJORIE: It is. It has been rather difficult. This is the key. We need the newspapers' support now to keep that concept that we had at independence, that excitement. But that is not unusual. In a marriage for instance, or a job that you take on, you will also find that the first excitement wanes and you have to work at it. It does seem

in a very strange sort of way that the spirit of co-operation which has built in our recent crises may be reminding us that we can work at it when we are sufficiently moved.[1]

KURIA: Having read your works, although you say that you are not particularly interested in being categorised as a woman writer, I notice that besides being set in Kenya, the main characters are almost always women. Is that because you are particularly interested in women? Or are you consciously interested in writing about women?

MARJORIE: I find that hard to answer. Of course I know more about women than I know about men, therefore a lot of my perceptions start there. Because I am a woman, a mother and a granny. It seems to me natural, though it is obvious that it does not appear natural to a great many of my colleagues, female colleagues, that to be preoccupied particularly with women's issues is something that is a woman's responsibility. *Chira*, of course is more...it takes the main character as being a young woman...it is a fairly deliberate attempt to explore the beliefs of that person. By and by, that is the nearest to an answer that I can come. But if you look carefully at the poems, some of which are now being given prominence in Kenya, 'Mathenge', for instance, they deal with issues that have to be explored by all Kenyans.

KURIA: Would you say that there are some problems in Kenya that particularly affect women and which therefore mean that women should be particularly more concerned about?

MARJORIE: Well, there is one major problem, I mean this is so obvious, I am sorry, I am saying it all the time, the major problem that we should obviously admit is that two hundred children die of preventable causes every day. And that two hundred is probably a very low estimate. It seems to me that any normal woman should wake up in the morning remembering this. Any woman who has undertaken that enormous enterprise of having children, and this essentially should be a matter of deliberate choice, should be asking herself every morning, am I really able to do this and please God,

help me. If I have to be employed or in some other need, am I going to in any way diminish the childhood that these children have a right to expect, please show me what to do about it. This to me is completely overriding. Last week we were talking about something else in the *Daily Nation*. I wrote to the *Daily Nation* saying that although we are terribly sorry that 145 people or whatever died in the bomb blast, this isn't really making very much difference to the total death statistics in Kenya and while a lot of those people died because we do not, as a community, know how to deal with that kind of an emergency, those two hundred children who die every day, die from things that we very well know how to deal with. And in many countries this would be seen as a disaster. While pages and pages were taken up with the explosion, there was a tiny little paragraph of about 8 lines which said that a one year old baby was burnt to death and her brother seriously burnt because they were locked in a house which caught fire! Nothing is said about a criminal case following the burning. This, to me, is the absolute problem that we have in Kenya that we do not regard as important. And that letter of course has not been published and no doubt now we know it has not been published because we do not see that as being very important.[2] So my very awkward novel, *Homing In*, which a lot of people have first misunderstood, is as well as an attempt to point how we come to have... because I was saying to myself, now I have to trace other parts of my history and this is part of my history whether we like it or not. And of course the situation of the incoming farmer or commercial person is very different and much more limiting than the situation of the incoming missionary because they are otherwise educated, they are otherwise located, but as well as that it is the story of a woman who comes home to a country where child life is of paramount importance, where it is considered fairly important and therefore loses contact with her children. As simple as that. Sorry but that is where I stand.

KURIA: When I was beginning this project, I went around looking for information on women's writing from Kenya. I noticed that your name is hardly ever mentioned. But when I read your works, I find

that your writing is as Kenyan as any can be. That is why I began by asking you whether you consider yourself a Kenyan. *Chira*, for example, has these two men in the opening chapter who meet outside GPO in Nairobi and shake hands. It is obvious that the handshake is scripted by someone who understands the role of greetings as a social discourse in Kenya. Do you think that your works of art have been given as much attention as they deserve?

MARJORIE: Probably they have received more attention than they should. I mean the fact that you are here shows that the attention is there. There has been an American critic writing about them but what I keep trying to say, and I think it is perhaps significant, that not only the letter I spoke to you about the children but even things I might want to say about artistic production do not get published in the papers. They dig out those old file photos of me when they have got a bit of space and cannot fill it...I mean I cannot say that I have not had attention in the press, I have had more than enough, but what I keep trying to say is that you do not write a novel to be studied in an institution and you do not write it for people to write theses about, even though you want to write one yourself, and I do not want to stop you, but this is not what it is for! It is for people to read on the Matatus, offices, students in byways. But everything we do is taken at such a serious level, you see...so that sometimes even the differences within one's own work are not really appreciated. I have a sense, I do not know Meja Mwangi, but I have a sense that he is also aware of this. That he operates on several levels. Maillu of course is on many levels. Actually Maillu has in that way more to complain of than myself. He really is not taken seriously at the level in which he should be taken seriously, because people's attention is stagnated. There is this terrible sort of snobbishness and perhaps a feeling that because it is necessary to... you pick a few writers and call them important. But really, old fashioned as it may be to say so, there is a test of time and a test of place. It seems to me some of the most distinguished set books that we have had in our schools have been the ones that came from India, *So Many Hungers*, because when you read such a book, you apprehend where it touches your community. But you are not aware

of where this happened because this is Luo or a Kikuyu or because she went to a mission school. You have to take those people as they are depicted in the novel. It seems to me that there is a very great risk that we take Kenyan books, which have not yet stood the test of time, and then we have people answering questions not out of the text but out of what they know of the situation which is out there. And it seems to me that this is not a literary approach.

KURIA: That brings me back to the issue of categorisation. I am sorry to have to keep coming back to it but that is my interest now. Would you think that it is sometimes because of that categorisation, you know such as defining an African in a particular way or Kenyan in a particular way, that some of those prejudices get into the kinds of texts that we look at when we choose what we regard as Kenyan writing? That some of us may look at you and say that your face is white and for that reason we do not want to give you prominence as a Kenyan writer. Is that possible?

MARJORIE: That may be so. I am not sure that this is at all important. I mean you throw your better part over the waters and it will come back to you in the fullness of time. I do not have any fear that I have any barrier with people of your generation. Maybe there are some in my generation. I do not think it is useful to pursue a problem that a person may have with you because of either ethnicity, religious outlook, gender, or your opinions. I do not think I have anything to grumble about that. Because if people tend to tell you we have particular problems in Kenya...I am not aware of any situation in Kenya in which our problems are not exactly the same as the problems of the men. Now I know that there are some countries, particularly Islamic countries, where people have had problems in publishing books, but if we begin dividing into women writers, then we are leaving the associations we already have to the men. It is not quite fair that we should have two organisations.

KURIA: Let me now come to the issue of feminism, which I told you I am interested in. Let us suppose that we have a feminist who is Luo and another who is British, do you think that they would or should approach things differently?

MARJORIE: I am not really a very suitable person to ask about that because as you have already established, I am not very sympathetic to this movement. Perhaps I should be grateful that the movement has helped publish some things in some places. But I find this whole situation difficult, because I have never doubted that it is a privilege to be a woman. You would expect that a person who calls herself feminist would like being a woman. But in fact many people who call themselves feminists seem to go out of their way to emulate men! And that I find difficult to understand. But that is a generalisation of things. I suspect, but I cannot say for sure, that one major difference between a British feminist and a Luo feminist, although this is a situation I am trying to avoid, is that the British feminist would be fairly well aware that she is not bound to have a child unless she has time for it and that she has and has had, for generations and centuries, a choice of marrying or not marrying. Right up to the time I was a child, a woman with a career was normally a single person and had probably made a choice when she might marry and have children. And because, historically, our culture has had a community system of care for children, which is now broken down at the core, although we do of course need to maintain it to some extent… that call[3] was from my Kikuyu daughter-in-law to say that four children had just been brought early in the morning and by the time she got up the father had gone and she needs to go to work. The four children, with whom she is not well acquainted, are just there. Although that kind of practice is still there in part, largely the community care system has gone.

KURIA: Yes

MARJORIE: There is a difference in marriage. But since I have not lived in Britain recently let me not talk about that now. But we were brought out to assume or rather knowing that many people would not get married. My attitudes were certainly influenced, and if you want reference for this you can find them in my *Moral Issues in Kenya* published by Uzima press, I do not know whether you have seen it, but my views were affected by the inter-war generation in which I grew up. There were enormous number of single women whose potential husbands had been killed in the first world war…

men left the very special place they had in society, and it looked very obvious to us those days that those were slots that women would have to fill because one had families that would potentially grow up and who needed a place in society, financially and psychologically. In the second world war, the slaughter of course was more indiscriminate. Although more men than women died, in Britain at least, but still a lot of women died so it did not have such a terrific imbalance. Obviously our attitudes were affected.

KURIA: Although you say you are not sympathetic to the movement, I think those are ideas which we need to deal with in Africa because in my own research I have noticed that most of the African women writers are not exactly sympathetic to the feminist movement. Writers such as Buchi Emecheta, Flora Nwapa, Ama Ata Aidoo have at one time or the other rejected that term. In fact I was intending to ask you why African women repudiate that term even when they are dealing with issues particularly relating to women.

MARJORIE: I do not think that I can answer that question because as I said I have tried to keep away from places where this debate is there. But what I would like to say, and this is one of the many things I have written about, though not necessarily published, that there is a tendency among Kenyans, which is very distressing to me, to down play the role of women in traditions. Perhaps I was fortunate, I married into a family in which my mother-in-law was very much a dominant member. She was very much an understanding and sympathetic person. She was an inherited widow, so that in her own homestead she was, you know this is properly the interpretation, the widow symbolically becomes the head of the first husband's home, the inheritor and the children of his other wife are not normally much on the scene... And now we are told presumably for aid promotions reasons that African women for one thing are poor, well yes, many people are poor but a community in which the men are rich and the women are poor is already a broken up community and to me that does not make sense. That they are not decision-makers, that they need to be educated or informed by young girls from the University or from America of their rights and duties. This to me is completely false to the picture. I see it in

Luo society... that rural areas are very much dominated... are largely dominated by women because the stronger of the men have left and gone to work outside so that the men who are left are probably those that are not the strongest; that women have control of the produce of the farm and personnel; that the woman is the one who dictates what must be done, and in many cases also she is very aware of things like electoral issues, and she is also well aware of women's groups offering loans etc. We had a very moving example of this when my husband was diagnosed with a terminal illness, and his mother had died long before, but there was a co-wife without children of her own who was very fond of him. I hesitated whether to bring her to Nairobi because I feared to upset her. One morning there was a ring at the door and there was granny. Standing there. She knew that Dan was sick, had to wait until somebody was coming to Nairobi who could show her the house even though she had been here before she would not be able to find her way here, she had borrowed money from the women's co-operative of her area, knowing of course that we would pay it, and there she was! And she behaved with perfect dignity. I mean there were no tears, there was nothing that could upset the patient. I felt very humbled that I had not trusted her sufficiently in that situation. I was very happy and spent that week with her and then she went home.

KURIA: Splendid.

MARJORIE: It seems to me that we are not so insufficient. Excuse me, I do not know much about your society but in Luo society, and I think by and large the African society, I see that the woman is very circumscribed during the period of her fertility because in times when population is scarce, her fertility is a major, major asset to the community. And therefore she is hedged in so that her fertility can be supplied to the right place. But before she becomes productive and again in her old age, she is freed of many of these restrictions. I mean she can eat meat, drink alcohol and smoke. She may not in fact do so because she had gotten used to fruits and vegetables but she is freed from those restrictions. She can now raise her voice in quite a number of things. I do not mean to say that there is a lot of advocacy among men in many communities...I do think

we down play the role of women and we should be respecting it and I suspect this is also happening in other countries. There was a wide range of activities which were open to women without male interference.

KURIA: This is interesting. I think that you are saying that in reference to positions of power, we would not say that the African woman is or was absolutely powerless. There were institutions that gave women power. I think that is what you are trying to say.

MARJORIE: Yes, they gave women power. There were institutions even very small ones. For instance, if a girl was captured, usually called marriage by capture but it was of course pre-arranged, but if a girl was really unwilling to go, she was to stand on an anthill facing in the direction of her home and refuse. If you did not respect that her refusal, there was very strong chira, there was a strong taboo.

KURIA: That is very interesting.

MARJORIE: That is what I have been told. I have never seen it happen but it was there.

KURIA: Now let me take you back to the idea of ethnicity. In recent times there has been whipping up of ethnic sentiments. You know people talking about their tribes, tribalism is perhaps the correct word to use here. Do you think that that will affect the idea of sisterhood amongst women in Kenya?

MARJORIE: I am not aware of it, but it may be. But again, if you look traditionally, we were taught that in times of war, which may be between Kikuyu and Maasai, nonetheless the women could hold their markets. So I wonder if there could not be something that could be built on. And perhaps this demand of western feminists that anybody can do anything, you know, if you want to take specific situations, makes the matters worse because you are no longer seen as outside the conflict. I have in my shelves one of the novels of R.C. Hutchinson, I do not know whether you know of him...

KURIA: No I do not.

MARJORIE: A very considerable British novelist who was writing in the 1930s to the 1950s and who it seems to me did not get the attention that he deserved because his themes were rather painful. And on the back of this old edition of his novel, which I bought in the market here,[4] there is a quote from another male novelist saying that R.C. Hutchinson is the most distinguished male novelist of this generation in England. I mean, that to me is a very natural thing. If you look at that particular time you will find that women were dominant in the novel. So this seems a perfectly natural kind of criticism to me. But in reverse we do not accept it. It would appear to me that in all communities, the arts, and singing, dancing, pottery and by analogy writing have been areas in which women have had a good deal of equality. In some societies, perhaps, we were not made to necessarily know, and there is a feminist project for which I have a greater deal of respect which seeks out historical examples of women's writing. And then you can have something to say that this song is there. Nobody knows where it has come from but some were traditionally sung by women. So you can assume that maybe that was composed by a woman but then I have also come to see that some have changed from generation to generation to fit different situations. In this area of the arts, I think there is room for argument as opposed to writing in the West because writing is something you can do at home, not like the plastic arts that need a lot of materials and space and so on.

KURIA: I have noticed that your writings have very many Luo words, which is natural as you have already pointed out, but do you ever think of ethnic pluralism as you write? Does ethnic pluralism in Kenya affect your writings?

MARJORIE: Ya. I think my poem on Mathenge, which was written some time in 1983, was the first time I really felt sufficiently involved to write something about the Kikuyu. It took me a lot of time and reading, whether it is right or wrong you judge for yourself but this was very conscious. And then when I came to write *The Present Moment*, which was written between 1985... because ... the publication of *The Story of Kenya* was delayed I was set to do it in a very short time schedule. With *The Present Moment*, I felt

very convinced that this is the time that we should not always be heckling over the cracks, we should learn to deal with the kind of the slight irritation that comes between the old ladies in the home. We should be able to express things. That was very conscious. In *Homing In*, Martha is a Kikuyu simply because physically or geographically in that area, it was most probable though not essential that a woman serving the white lady would be a Kikuyu although a man serving might have come from a greater distance. Whether I got it or not is a matter of conjecture.

KURIA: As we draw toward the end, let me ask you a question that is perhaps inspired by my being a man. Sometimes I feel that when activists and scholars are talking about women's liberation, they talk of women changing, women changing, and women changing. And I wonder whether we are not placing too much onus on women to change rather than men to change. For example, perhaps rather than women changing to become smokers and drinkers, should not the emphasis be on men smoking and drinking less?

MARJORIE: Well there I would be with you. There has been a change in that you see a man in a generation younger than me, I mean in my generation you do not find fathers changing babies or being much intimately concerned with the processes. Even our very good fathers who tried to play with us would have done no such a thing. But I think, as I said before when we were talking about ethnicity, there are certain European values that you tend to project when you come and start arguing and then come to see that this is why someone did this or the other. I think even in the feminist movement there was a sort of initial revolt that went a bit far and now you are getting a bit more balanced activism. I wonder, for example, whether you have heard of this children's match in America. Now you know there was the one million men match, then there was a moment, I think it was in 1996, when there was going to be a similar match for children's rights because it was time when the government was cutting children's subsidies. And Betty Friedan wrote and said, we have got all to support this because whatever our views about other things, about sex and so on, there is no point saying that we are freeing women if the next generation is

not surviving. We must, as women, act together. I was very much moved by this. My daughter tells me that having gone to some extremes women are now seeing that there are some biological responsibilities that they have which, as it were, cannot be thrown off.

KURIA: Finally let me ask you about your growing up and becoming a writer. How did that come about?

MARJORIE: Ever since I can remember, I wanted to be a writer. I was always read to as a small child by my parents and my maternal grandparents. I cannot remember a time when I was not reading. As long as I can remember I was always writing things. But let me say that writing is the channel that I feel God has given me to approach a lot of things and issues which are important and that does not mean that they are religious, but they are issues in society. If I have made mistakes about this, well I am getting older and hopefully will soon find out. But basically, as a Christian you have to accept that maybe there are some things that you are not allowed to have.

KURIA: Which of your books do you like most?

MARJORIE: I like *The Present Moment*.

KURIA: *The Present Moment?*

MARJORIE: Yes.

KURIA: Why?

MARJORIE: Why... It seems to me that it sort of puts together a lot of the things that I have been dealing with. Maybe I like it because the gestation period was less painful than some of the others because I had already done research as I was writing *The Story of Kenya*.

KURIA: I was quite struck by *Victoria*. I was thinking about the puns that can be found in that word Victoria. It can be Queen Victoria, it can be the lake, and has the word victor in it. I am wondering whether you were thinking about all these when you wrote it.

MARJORIE: Well, the name is there in *Murder*. The genesis of this book is that when Oxford had published *Murder in Majengo,* Jonathan Kariara, with whom I had a great deal of partnership in the writing of poetry, said to me, you see in this book you have suppressed the main character. She is in prison all the time. You have got to do something about it. I wrote this novel mostly when I was in Tanzania but I did not send it to them until we got back to Kenya. That was because I felt the need to test it here first. By that time the series of African writers had been discontinued because there had been something about the franchise, so they were not able to publish it. So this novel sort of hung around for quite some time and because it was related in one angle to one publisher, I could not get another publisher for it. There are some constraints in that novel because it is a sequel to *Murder in Majengo*. And of course ought to have come after *Murder in Majengo* but I could not persuade those editors that it was so.

KURIA: Yes.

MARJORIE: In view of the things that you have been asking me, it is important to note that this novel was written in the mid-seventies. Victoria as a shopkeeper, although not very successful but still having the opportunity to do it and the other women characters like the sister who is her friend and so on, these were recognisable in society. Was that 25 years ago? So the notion that these people have only come up because of the kind of gender based organisations which we have is actually not true. More of them may have come up but I mean there wasn't the women's bank for instance in those days. A lot of these co-operative groups were just beginning to come up. But the women were still there running their own businesses.

KURIA: Thank you very much for sparing time for this interview.

MARJORIE: Well thank you too for coming and wish you all the best. I am sure you have quite a number of interviews to carry out.

KURIA: Yes. Thank you.

NOTES

[1] The 1998 bombing of the U.S. embassy in Nairobi took place a few days prior to the interview. Opposition leaders joined hands with the government to condemn the attack and raise support for the victims.
[2] That letter was subsequently published in the *Nation* of 24th August 1998.
[3] Macgoye had just come back from answering a call from her daughter during the interview.
[4] In reference to an open market very near her house.

GRACE OGOT

GRACE OGOT

INTRODUCTION

Grace Ogot is undoubtedly one of the most prolific Kenyan women writers and one who, to use Oludhe's words (see interview), has stood the test of time. She was born Grace Emily Akinyi in 1930 in Asembo Kabondo sub-location, Butere, in central Nyanza district of rural western Kenya. She attended Ngiya girls' school and Butere high school before proceeding to Mengo Nursing Training hospital in Uganda where she trained as a nurse. She later worked as an announcer and script writer with the BBC in London from 1955 to 1958. In 1959, she married Bethwell Alan Ogot, now a well known Kenyan historian, with whom she had three children: two boys and a girl. Between 1959 and 1961 Ogot lived in London with her husband who was pursuing his doctoral studies. Ogot can be classified as one of Africa's leading women achievers. This is attested to by her accomplishments both as a creative writer and a leader. She was the first anglophone Kenyan woman writer to be published, with short stories appearing in 1962 and 1964. Her first novel, *The Promised Land*, was published in 1966 which was the same year as Flora Nwapa's *Efuru*. In 1975, she served as a Kenyan delegate to the general assembly of the United Nations. In the following year, 1976, she was a member of the Kenyan delegation to UNESCO. In the same year, she was the chairperson of the Writers Association of Kenya of which she had been one of the founder members. She first served as a nominated member of parliament in 1983 before being elected to represent Gem after its incumbent member, Horace Owiti, was murdered in 1985. She was re-elected in 1988 and appointed to the cabinet as an assistant minister for culture and social services. She lost her seat in the 1992 multiparty elections which, in her opinion (Ogot 1998), was because she ran on a KANU[1] ticket, the ruling party, in an opposition dominated western Kenya. She has

to her credit three novels: *The Promised Land, The Graduate* and *The Strange Bride*; plus three volumes of short stories: *The Other Woman, The Island of Tears* and *Land Without Thunder*. Her major concerns in her writing include marriage and family relationships, with special reference to wife/husband relationships. She is also interested in the marginalisation of women in the public domain contrary to provisions for their involvement within the traditional structures of Luo society. In a 1979 interview with Lindfors (1979) she attributes her emergence as a writer to traditional stories narrated by her grandmother. She also argues that her interest in the relationship and tensions between traditional medicine and modern medicine is inspired by her training as a nurse. This interview took place at the Kanu headquarters, Kenyatta International Conference centre, on the 17th of October 1998.

KURIA: In my conversation with you earlier you were saying that as a writer reconstructing oral narratives you sometimes have to change some things.

OGOT: You do not actually change but as a creative writer you are not a recorder. At times there are some bridges that help you jump over rivers but you may also go round them. Because you are not a recorder. You are not recording. That is how you may find variations. All you need to do is stick to the story line.

KURIA: Now there is something that you talked about which I would like to revisit. We were talking about the place of Luo women, men and polygamy. I find that when I am reading most of Luo literature, some of yours included, that a man did not just go out there and get married to another woman. It looks as if the first wife would tell the man, 'You need to get married and may be you need to check out on that one'.

OGOT: It is happening even now. In the traditional society you needed extra hands for work. Maybe the eldest wife was sickly or maybe the eldest wife did not have children, or not enough

of them any way, and during the time when there were wars they needed somebody to be with them at home when men went to war. But later on you needed extra hands and company. A man would not be mean about it. A man would just say to the eldest wife, 'I think now there is too much work in the garden for you. Your health is not very good and you have this and that to attend to. Maybe we should get another mother to come and help you'. Come and help the woman. They did not say come and make me happy. And the woman would say yes. Immediately she says that she would start checking among her people. The new wife would not be a stranger. She would be from among her people, her sisters, her aunts etc. It may have been somebody so and so had talked about. That was one aspect. The other aspect was that it was the wife who would approach it. She would say to her husband, 'I see that there is too much work for me and my health is not very good and in our home (or another relative) the daughter of so and so seems to be a good breed'. And then they would discuss it and then other people would be involved in it. That is how it happened. So whoever would be coming would be coming to that home knowing that mother is there. The eldest wife is there. And the new wife would never call the eldest wife by name. She would make sure that she is cooking in the eldest wife's house before later on when her own children would start coming. When the new wife moved into her own house, the eldest wife would help establish her and therefore there would be unity and harmony. But it is different now. It changed with modernisation.

KURIA: Would you therefore say that there is a way in which modernisation has ruined the institution or that things were better off then than now because now men have one wife at home and multiple others outside? Would you say that in a sense it is worse now because then at least you knew who your co-wife was?

OGOT: They are saying it openly. Better the devil you know. And the one who is here at home will not be wasteful unlike the one outside for whom you have rented a house, you are trying to get

a car and getting this and that for while the wife at home is unaware and starving. If they were both at home wealth would be shared. That is how the women feel about it now. And it is dishonest to hide all these things from the wife.

KURIA: So there is a way in which the polygamous system was a better system for women than the loose system that is in place now?

OGOT: In fact I do not even want to say was a better system, is a better system. The one outside is the one carrying diseases and is also the one that is plundering family wealth. That, at least, is what even the younger girls feel. And some people are putting too much demand on women. After all a man is a friend of the woman. A woman of the house does not want to feel that her husband is being exploited elsewhere where there are other men! She wants to feel that it is good to know who her regular member of the family is and that it is better for them to be around also to share problems.

KURIA: My reading of Luo literature also seems to suggest that the position occupied by the first wife was a position of power vis-a vis not only the other wives but also the husband. Could you explain that to me.

OGOT: Yes, and she is still holding it now because she has a name: *Mikaye*. Very honourable. The first wife, the one with authority. The founder of the marriage. And the others also have a name: *Nyachira*; the one who comes after the first wife. *Mikaye* is respected by the village. She is the spokesman of the home. When *Nyachira* comes in, she will be loved and respected but then she has the *Mikaye* as her spokesperson. *Mikaye* is the one who will first get out the seeds for the plantations. Her farm will be the first to be ploughed and planted even in the modern times. And then she is the one who will bring home the first harvest and taste it before the others. The door of her house faces directly the gate. The others will be on the right hand or the left hand.

KURIA: I am following up on this one because I find it very interesting and as you have told me before it is not there among the Kikuyu.

OGOT: Yes

Kuria: And also I realise that most western critics read these institutions as basically oppressive to women. But my own examination of its rendition by African women writers seems to suggest something different.

OGOT: The reason why it is not oppressive and in my writings men will never fall apart is that the Luo community has no divorce. There is no divorce in Luo land even when you go to court.

KURIA: There is no divorce?

OGOT: There is no divorce! That paper...

KURIA: Is not recognised?

OGOT: Is no divorce. In death they will bring her back if she has not married elsewhere. It is happening everywhere. They bring her back. She never got married. That is why they bring her back. She has no burial place elsewhere. What I was trying to tell you is that when a boy is born his burial place is already determined. Just like the first wife. Her burial place is also determined. So is the second one. Now a boy child, first boy, his burial place is determined. It is where he will put his house. It is determined even before he gets married. His *simba*.[2] A girl, hers is not determined because you grow up, get education or whatever and then you get married.

KURIA: Are you saying that for a Luo woman marriage determines your burial place?

OGOT: When you are born your destiny is marriage. When you die your burial place is at your husband's place. And that is why for a Luo girl marriage was and is still so important and will remain important. Because you have no burial place at your birthplace. Now, in modern times, and as I told you I have been a member

of parliament and a leader for the last twenty years, it is being reversed. Even among the Luo there are not enough men to go round. The women are more than the men. This is exacerbated by the slow demise of polygamy which is dying a natural death because of economy, as you know if you marry among the Luo community you have to feed your wives, look after them, equally give them wealth and educate all the children. So there are more girls as opposed to men because polygamy is dying. To that end we are saying, even those who are younger than me, get it from me there will be many Luo women not getting husbands even if they are craving to get married. They will not get husbands to marry them. It is the duty of the Luos now, and they have started doing it, to change so that at birth a girl will also be considered for a burial place so that should she not get married...

KURIA: She can get a place for burial in her father's homestead?...

OGOT: She has a place to get married because for us burial is very important. We value the dead.

KURIA: Were there ever cases where a woman never got married, grew old and died?

OGOT: Yes.

KURIA: And what happened?

OGOT: She was buried outside the home and they are still being buried outside the home. In Gem where I was and still is a leader they know – they call me *Mama*, they have given me that name – they know that you call *Mama* to the burial of a girl *Mama* will not stay if you are burying outside the homestead. And *Mama* will not speak but will weep all the way lamenting that in the evening you will close the gate and you are closing the dead girl outside. So now burying the single girl in the home is catching on. And in burying you outside your degree does not count.

KURIA: It does not matter what you have?

OGOT: It does not count. You are a single woman. That is why when people are saying that Ogot is fussy, no, I am not fussy. These are realities that I live with and that I have talked about and now there are changes taking place.

KURIA: Now, in traditional Luo land if a woman was unhappy with something and she wanted change what would she do?

OGOT: Well, there have been changes. The Luo community also loves change. They are not static. But there are practices that are still on like bride price. It is on, there is marriage. It is not on, there is no marriage. Like wife inheritance. It is part and parcel of the system. But then there are others who will say no to these things. I am one of them that will never be inherited because there is no reason for it. When Tom Mboya died, I told somebody nicely that there must be a certain man whose wife cannot be inherited. I cannot see anybody wanting to inherit Grace. Because she is such a person. So there are women who feel like that. But the majority feel it is the normal thing to do. In traditional society the Luo had the best. The widow was respected and cared for so they did not *tanga tanga*[3] with the children. And note this, the children born after the husband's death were the husband's children. That is where the Luo community differs with other communities. That is why it is honourable. You give birth to them but they are the dead husband's children. They are not yours. They do not carry your name.

KURIA: They do not even carry your name?

Ogot: No, they are not yours. They are born in his house. You only came to assist the woman. The woman would never come to your house. They stay in their home. They shared wealth but they were for the woman. And it was very very honourable. But because times have changed we want the community also to change so that the traditional woman remains to be inherited, while the modern woman who knows that her husband was so and so and does not want be inherited, then she can have her freedom. As the time goes by people will have a choice.

KURIA: Does that mean that inheritance was not a forced thing but it was something that also emanated from the woman herself?

OGOT: Yes indeed... you had a choice. Ya!

KURIA: Oh, you had a choice?

OGOT: You had a choice!

KURIA: Even if you wanted to say no...

OGOT: No. You had a choice on who would inherit you. It was not automatic. You had a choice. And you know that widows never accepted gifts but if you do accept from one it is a cue to the family, *huyu huyu, diyo, huyo atatega*.[4] You had a choice.

KURIA: Alright. If we could move on to another issue, *The Strange Bride*, is it an accurate rendition of the Luo myth or did you rework it and if you did why?

OGOT: Nyako Nyawir, which is her name, is just a simple story. You could be having somebody wearing a dress but the skeleton is the same. The flesh may be a little more here a little more there but the skeleton is the same. It is Nyawir who changed what had been from generations.

KURIA: I am asking that because the lady is in my opinion revolutionary. Although she brought the Luos work it is also through her that wealth, in terms of cattle at least, came into Luo land. Is that the same way it is in the mythology?

OGOT: It is so in the mythology. Remember also that there are people who are extraordinarily strong. Even in politics. And with that, goodness must also come. There are also times when one particular story can be linked to another myth in order to make it complete instead of writing two different stories.

KURIA: It is an extraordinary story.

OGOT: I wish you were able to read *Sibi Nyaima*, but any way you will get it because some of your Luo students can always translate

it. If I was not very crowded I would start translating it now. *The Strange Bride, Miaha*, was very authentic. The translation did not grip it all. Then later on if I get reviews of *Miaha* in English and also *Sibi Nyaima* in Luo I will just try and get them to give you a rough idea.

KURIA: That would be a great idea. I have always felt that if there was any language in Kenya outside my mother tongue that I would like to learn it would be Luo. It is very rich and Luos are very concerned about keeping their Luoness. For me that is very important even as the world becomes a global village. I think we need not forget our identity as Kikuyus or Luos.

OGOT: Yes, that is why marriage and death are very very closely related to birth. There are things that must be done in a proper way and in continuity. But modernisation is a part of life as well.

KURIA: Maybe we can just move on to customs. Are there some customs that you feel are oppressive to women?

OGOT: Yes. I think that inheritance is oppressive to women. Because there are women who say no. They do not need it. They could be chief executives in town. And do not think that all Luo women are rebels like me. No they are not. They are caught in a network of traditions from birth. An executive may be highly educated but her father is not. Her father will always remind her, 'if you do this or that bad luck will follow'. If that continues it is oppressive to women. A woman executive being inherited by a brother-in-law who never bothered to even complete school and all he is waiting for is to get that car, that house, that wealth or that bank book is oppressive. Women were born free and should be free. And so there must be a time when a Luo woman can choose to be inherited or not to be inherited. In the modern world inheritance brings a lot of sickness to the women and to the family. It deprives the real inheritors of the family wealth and gives it to another family whose father never struggled. That is one.

KURIA: Yes

OGOT: Two, polygamy is oppressive. A woman who married a man because she loved him above anything else should not have to be caught up in polygamy with a dinghy little girl who first of all had no idea what education was all about and who is coming here to just destroy or annoy. Or it may even be another well educated woman who should be able to get her own husband but she comes in and is unfriendly. You see, if she is friendly you can like them. But she is unfriendly. She tells the husband, 'if you love me, get rid of so and so before I come in'. The bitter war starts here which could destroy everything.

KURIA: But then that is not Luo custom, is it? If a man marries another woman without the consent of his first wife and the new wife acts negatively to the older wife that would not be Luo custom, would it?

OGOT: Well, but as you have noticed among the Kikuyu most customs are on the road to going. They are going. And because they are going, not getting the eldest wife's consent is part of the going. A husband no longer thinks it is important to get the consent of the first wife.

KURIA: Isn't that the problem? That we are insisting on some traditions without taking into consideration the way they were operated?

OGOT: Yes, that is the problem. And most of the consent has gone. Hence the problem of the graduate you married. You are a graduate she is a graduate. You are a medical doctor or Ph.D and so she is. In reality what used to be the basis of a co-wife has shifted. It isn't that you need extra hands, it isn't that she is sick and it isn't that she is disabled. She is very strong but you feel no, you want extramarital affairs and instead of doing it out there you want to bring her in. My appeal to the men is that in order to create harmony you tell your spouse that you want to bring another wife.

KURIA: If you must get a second wife?

OGOT: Yes, if you must. You should tell her you want to bring another wife. And then do not insist. Remember also that traditionally each Luo woman must have her house where God can help her give birth to her children and bring them up. You can never have a bedroom for one woman and a bedroom for another. It is uncustomary and it will kill the old wife. So you agree that *hata kama anakataa*,[5] even if she refuses, at least make sure they have their own places.

KURIA: And they know each other? *Sio ya Kuficha.*[6]

OGOT: And why not know each other? If you must do it. Because it is not only the African who is polygamous. Everybody is polygamous in all their countries although successive. *Unadivorce huyu unachukua huyu unadivorce huyu*[7]... I think that is terrible. *Vizuri yeye kuwa iko hata kama wewe naongeza ingine.*[8] Where will she go with the children?

KURIA: So you would rather the African one rather than the successive one?

OGOT: Yes

KURIA: What role do you think outsiders, be they Kikuyus or Europeans, can or should play in changing Luo customs?

OGOT: What I have told you really touches on the Wambui case[9] and why Otieno could not be buried elsewhere. Now, our children have married the Kikuyus. Our customs are different. When Bishop Okulu's daughter married in Kiambu she was given a name, Wanja, as we give our own women a name. The day you are married you are given a name. In my speech, even when we were at the celebrations, I told Wanja, 'my daughter, now you are marrying a Kikuyu your children will be Kikuyu. Both boys and girls. Bring them up according to Kikuyu customs and traditions because they will be rulers in Kikuyu land'. That is what Wambui should have done. She is a very special friend.

KURIA: In other words she ought to have realised that she had married into Luo land? That reminds me, there is this book by Atieno Odhiambo and Cohen and they quote you...

OGOT: Were they at the funeral? Did they get what we said as a community or individually?

KURIA: Even as individuals...

OGOT: Did they? Kuria you know why I have been talking to you out of context? My literature, yes, but customs are very important. If you do not want to be an ordinary professor at a superficial level get these customs. Kikuyu and the Luos are the basic although later on you can look at the Kalenjins. Some are so fundamentally different but the basic Kikuyu and Luo get them. Things like birth and burial are very different. Kikuyus will leave the mortuary in the morning and burial takes place in the deceased's shamba at mid-day,

KURIA: Or two hours later...

OGOT: The Luo must sleep in her house or his house. In Nairobi *alale hapo, alafu nyumbani alale diyo azikwe*.[10] On marriage Kikuyus are different. Luos are different. Our daughters must know that. You marry a Kikuyu, there are fundamental differences. You are a Kikuyu. We tell them! There is one married in our home, one day you will meet her. She speaks Luo better than me. She knows the customs.

KURIA: And that is the way it should be, shouldn't it?

OGOT: Yes, that is the way it should be.

KURIA: I was talking to Marjorie Oludhe Macgoye the other day and she told me that she considers herself Luo.

OGOT: Typical. She has often reminded me of what should be done. And so when the Wambui Otieno case came up and became protracted that is what I was trying to get at.

KURIA: I can see the point. There is a way in which, in spite of progress and the changes that are taking place, men and women cannot just divorce themselves from customs and society. That is how I interpret your ideas on Wambui. You are suggesting that she was trying to divorce herself from a community.

OGOT: Which is hers by right through marriage.

KURIA: Yes

OGOT: And as you know when a Luo girl marries it's her right to inherit the shamba that her mother had. At that stage she is given her shamba immediately. Because we inherit through marriage all the good things that a Luo woman gets. In that very marriage where we say that she is oppressed she is also very important, especially the first wife. If I am separated from Allan or I am divorced and I am not married elsewhere, if he dies the men will come crawling on their knees to get me home.

KURIA: To get you home?

OGOT: Oh yes! How will you bury without her? Especially with this separation these days, you go crawling until she comes and sits. That is when people will come and start digging the grave and that is when other arrangements will also be done. And so although there are some which are oppressive, in Luo society the eldest wife is queen. In death or in other functions that must go on such as the marriage of a son or a daughter what will a man do without her? They will go crawling looking for her to come and do a, b, c. So while there are areas where she did not have a voice there are many places where she had a voice.

KURIA: Yes.

OGOT: For example, faced with decisions on many issues such as politics, community wars and so on, a man will tell you 'let me go and sleep over it'.

KURIA: Ah, that was the idea?

OGOT: She does not speak out there but there is give and take among the Luo community. That is why we stick to our marriages.

KURIA: Yes, and such things do come up in our writings and criticisms but we shelve them and yet they are powerful things.

OGOT: And you know that is what you are seeing it in *Miaha, The Strange Bride*. When Lwak, the mother-in-law, talks to the father-in-law constantly telling him, 'I think there is something here'. She will not say it in the market but back at home.

KURIA: At home?

OGOT: Yes, and she is heard.

KURIA: So would you say that outsiders looking at African customs in general have a role to play in suggesting those that are oppressive?

OGOT: I think that the society itself, among the women within the society and the enlightened men, can bring it about. Modernising and keeping some. You see, for example, a Kikuyu woman will build a house and roof it. A Luo woman will never touch it. No! How will she go up the roof to thatch a house? So if a house is leaking letters will come to Nairobi, 'come home or send us the money to have the leaking fixed'. You just move the bed and put a sufuria[11] there and let him come and do it. And people will deride the husband, 'even you drink here when your wife is living under a leaking roof even you?' This helps!

KURIA. Yes.

OGOT: For the women there are also some things which we do by choice. You never quarrel with your husband when there are visitors. Even if you were quarrelling and were near a fight and a car pulls in or you hear people at the gate, oh it stops there. Why embarrass your husband? Why wash your dirty linen in public? And it is you who will tell him there and then '*Wachana na hiyo*'.[12] Ah, you will run very quickly to prepare tea. And when the visitors go, you say, 'I only saved you this time!'

KURIA: Is that so?

OGOT: Yes. Note that even if there is no sugar or anything she will just take her own money to buy bread and sugar. When the visitors leave she will turn to him and say, 'I have always said you should leave some money at home. Now your visitors come and there is nothing at home! You are always hanging on the money'. And the man will also feel happy, '*kumbe amenilegezea*![13] If she has not embarrassed me with the visitors then I ought to treat her better'. Which husband will not soften because a woman has softened. But that is in our customs. Soften for your husband.

KURIA: You know among the Kikuyu we have a phrase, *cia mucii ti como*,[14] you know, you do not broadcast family secrets just like that.

OGOT: Yes. There are some good things to say about a Luo husband. A Luo husband will go drinking *lakini*[15]... he will run home and leave a pound or two, *na chakula*.[16] He will leave it before he goes to drink with the boys. That is also something. So there are some which are bad and there are some which are good. But a Luo husband will take care of his family. I mean the normal Luo man. He will take care of the house so that even if he comes home late he will find that the children have been fed. I am talking of the typical ones, I am not saying of this grade grade ones.

KURIA: The typical ones are the ones I am interested in.

OGOT: The typical one does not just go partying. He will drop something home even if he is poor before he goes drinking. When he comes home *huna maneno miingi*.[17]

KURIA: I think that we can accurately say that there is something wrong about disrupting some of those customs abruptly just like that...

OGOT: And Luo women, we do not agree with women who fight their husbands in public. It is unacceptable. It is unacceptable. It does not make sense. Why humiliate him any way. In the

same way, we are doing it so that a man does not come and just shout and quarrel with the wife where there are others. Those are some of the customs which should be weighed and kept. But inheritance has to go and only remain for those who need protection because that is what it was all meant for; for those who needed protection. Polygamy is a killer of families. It will continue but it will die gradually. But a man must learn to consult as they did in the past. Otherwise they die as a family. Any of us who does not want to consult in these things you have seen and will continue to see many casualties.

KURIA: Yes.

OGOT: In the Beijing conference I think that the Kenyan man misunderstood it. We did a jolly good job for the African man. A jolly good job among the communities of the world. We did a good job for them. One, a Kenyan woman, a Luo woman, an African woman, wants a happy marriage. In a happy marriage, a married woman must put in some percentage in that happiness, in that security. That is what we find with our husbands for us married women. You should put 60 percent in your marriage in order to be happy, secure, and respected. You want to put in 60 percent because you want your husband to respect and love you. If you do that a husband will put in 70, he will put in 70. And how does one go about it? I will give you an example. I was in Parliament. At 6.30 when the house rose I wanted to be home so that if Professor is coming home Professor will find me there. And when Professor finds me home a cup of tea will be ready for him. I am not a fool. If on Monday or a Tuesday *mwalimu alikunja akanipata niko nyumbani, chai iko, mtu anamfungulia mlango*[18] even if workers are there, on Wednesday and Thursday Allan would come home very early. Sometimes you may say, 'oh how come today you are this early' 'oh I knew you would be home', then that would become regular. Drinking with the boys of course but he will always know that Grace is at home. Later even if I go with the girls or with the boys, other parliamentarians, he will also be waiting. I am building my happiness. That is one aspect of it.

KURIA: Yes…

OGOT: In regard to respect, if I never shout at him when workers are there, when his relatives are around, I never shout at him, I never call him names, I never keep things around, he will never shout back. He will always know that it is give and take between individuals. For the European woman, I cook on a Monday, her husband cooks on Tuesday. For many of us it is not for him to be cooking in the kitchen. That was the Beijing message for Kenyan women. I do not think that an African woman would really bother that her husband does not come to cook in the Kitchen. In traditional society and in the rural village he would not enter a kitchen at all because he would be doing other things I do not want to do. You can also mention to me other areas where friction within the family can be avoided. I am taking the married woman first. You bring peace in the house, a husband will also bring it. And I am talking about a normal husband, a normal woman. They will not quarrel in front of the children. It demeans the woman and she might even be beaten for nothing. Do not get me wrong, wife beating is a big NO! to me. A wife is not a child. She is not your child. And even children are not to beaten nowadays.

KURIA: Yes.

OGOT: So wife beating, No! No! No! That is an enemy. In the absence of wife beating and there being harmony within the home I think that is how the African woman wants things to be. But an African woman does not make a rota for her husband to cook. I do not see any reason for that. In helping with shopping and many other things those are arrangements between you and your husband. For the single girl, an African, she has and should have a right for love, respect, maintenance of dignity and equal job opportunity for what she is qualified for. She has a right. Should she want to marry in a polygamous home she should go about it in the right way so that she is not at loggerheads with other women. Here I am talking of the executive woman. I sometimes think that the western woman, *anashika*[19] husband. *Anamwekea miti*.[20]

KURIA: That is true.

OGOT: She is oppressing him. Which is not within our culture. I do not shout to my husband but I am very powerful. I do not need to. In customary marriages you may be required to be docile here and there but in a modern sense you marry at par. But within the par you still are an African and you know your culture. An African woman can get many things from her husband. Many! To that effect the white woman will always look at it in a different way. It is the African women with varied cultures who could meet and converse regularly to see how they can modernise without destroying what cultures protect them. You know that in many societies like Luo land you do not easily divorce your wife. Your community will say no. Your family will say no. And so we are also protected within those cultural heritages.

KURIA: Good.

OGOT: And also a Luo woman will live in a happy marriage. She wants to cultivate her happiness within the family. On that she can also consult. Luo husbands are also willing to be talked to about varying things such as when they are mistreating their wives. They will take advice from male elders as well as female elders. So it gives us a leeway to cope with the pressure.

KURIA: Now being a leading figure as far as women's issues are concerned in Kenya...

OGOT: I am what?

KURIA: I mean you are one of the leading women in terms of championing for women's rights...

OGOT: Actually well-being.

KURIA: Well-being, yes. Would you confidently say, and I want to put it bluntly here, that African women do not mind being homemakers.

OGOT: I do not think they mind being homemakers. Homemaking is about families and once you are married your family is your husband, your in-laws, your children, your sisters, and your relatives. Many African women, many of them, are homemakers. And many Luo women are homemakers.

KURIA: And they do not mind?

OGOT: They do not mind. The rider is that for a Luo woman no major decision is made without her being consulted and contributing to its success. Whether there is an investment or a relationship which might injure the family her advice, like that of her husband, can be taken. Her advice, like that of her husband, can also be uppermost. Because she is the centre of that family. She will say to her husband, and this is off the record, '*Unaenda kununua*[21] thin ones *lakini*'[22] so and so has good breed. A husband should be willing to accept such advice. You know, 'why are you going to all those people? Why not buy there even if this is a little more costly?'

KURIA: Can we connect that to my final question. Do you consider yourself a feminist?

OGOT: Well, between us I have the meaning of the word feminist in their mother tongue, in the western sense. In the African sense how would you interpret it?

KURIA: Let us first handle it in the western sense for that word, agreeably, is a western word. Understood in its western context would you consider yourself a feminist?

OGOT: Western feminists have an idea that they want to perpetuate. I got married at 28, my best education was got in England before coming back to a very responsible position. Now, being a mother you are not only a mother of your children, you are also a mother of the husband and another to his people. Having only one daughter and three sons I am a little bit outnumbered. I think that in motherhood you can change the course of life for a society and for a people. And therefore I cannot be a

feminist. Unless I am getting them wrong. They have a certain ideology that they want to follow. If it does not happen this way for a feminist then life is crumbling. But for me I am looking at womanhood in a much wider context. What has always been on my lips is equal opportunity. And we are on the road to it. But I think it's moving too slowly. While in Kenya look at some of the boards that have been appointed of late including the Njonjo lead one, the one that will be distributing bomb blast benefits. There's one woman, very elderly woman, a white one. My view would have been that in order to give women an opportunity more women should have been there. And we are going to ask *Mzee*[23] to increase women. This is not just to give women an opportunity but it's because the woman is the home and the family. This is because she takes care of husbands, elderly people, men and women, all the sisters, all the brothers, some of whom the husband does not agree with, and she brings them all together.

KURIA: Yes.

OGOT: In societies where women are given opportunities they are humane. I must admit, however, that because of our upbringing, as women with little opportunities, it does not mean that a woman's pen promotes more women. For this reason we also want women to be liberated. Their pens are mean on women also. This is what society is looking for. It is looking for women who can promote women. As of now a woman gets a post there, she neither takes women for training nor promotes them. At the moment it is more men's pens promoting women as opposed to women being in high position. But we know that as the time goes by we would also like the women to do that. That is why I feel I am not a feminst.

KURIA: I do agree with you that because of western feminists' agenda, especially their positing feminism as a war between men and women, I think that in that context many African women may not want to identify with the movement.

OGOT: No.

KURIA: Actually the results of my research so far seem to be demonstrating that African women are not at war with men, but that they are saying that there are some wrong things that have been going on and that we, men and women, should revise them for the betterment of us all.

OGOT: Yes. You are absolutely right. And men can also be oppressed by women. When men are oppressed by women they become very aggressive in order to say they are top, they are boss. So just as I said, putting 60%, oh, oh husbands will put more. He will match it and surpass it. You put nothing into it, *ataweka*[24] more harassment. The West is different from us. For us we want to give our husbands, our brothers and our sons liberty. Culturally it is there but as I told you a very powerful man will always say 'let me sleep over it'. He will come and consult his small wife here. He will discuss what was at the meeting. 'They wanted me to do a, b, c, d, what do you think about it'. She will say it is good but...

KURIA: And then he will go and effect things as if he were the one doing it but it is actually the wife...

OGOT: They are doing it together. In some cases the wife will say no! Don't. So and so will only mislead us. And during the day she will say nothing. She will look her usual docile self.

KURIA: Actually might we say that the reason why African women do not want to be called feminists...

OGOT: It is not that they do not want to be called feminists, there is no way they can be. Many African women, many, are homemakers. And many African women are for the extended family. Even when she does not want they are there. So in town here a *mzungu*[25] does not live with brothers and sisters as we do. Even if they are in the village you are the one paying fees. You are the one who will get a *Ng'ombe*[26] for them to get married. So our situation with the extended family does not allow me to be a

feminist because feminists can be very rigid. They can be very very rigid but then they have been so from childhood. Even the highly educated African women, Kikuyus, Luos and all the others, they will always look back. Therefore, the main issue is equal opportunity and respect.

KURIA: When Westerners say women are now liberated they are perhaps looking at, among other things, certain behaviours of women such as drinking beer, smoking, less commitment to motherhood etc. Sometimes I am wondering whether those are necessarily good things.

OGOT: You mentioned something about liberation. *Fafanua*.[27]

KURIA: I mean that most of the women liberation activists...

OGOT: And they are here in Kenya do not forget.

KURIA: Yes, they are here in Kenya. It is like they are telling women, men have been drinking so come and also drink. Or if your husband is caught in adultery maybe you should also go and do it. I have a feeling that many African women would not want that. And I also feel that perhaps that is not the correct approach. Perhaps we should emphasise that men should stop drinking too much, stop being adulterous and things like that.

OGOT: There are two things we should separate. There is being an activist and a revolutionary, politically speaking. We separate the two. We separate the two in that the political approach is different from any other. You can be a political activist in which you can demonstrate in the streets, yell, do this and that and do what men do. But you can also be an activist within the societal issues which affect us. I will start with the fact that we are a little different. In marriage there is motherhood. Within motherhood there must be elements of caution. Liberation must be within the context of the society in which you live. The question is to be liberated from what and how? Politically, a Luo woman is liberated. I am not saying a girl, a Luo woman is liberated, she is accepted right from the days of Grace Onyango,

Jael Mbogo, Phoebe Asiyo, Grace Ogot, name them. They are loved, they are voted for, they are given the respect they deserve. And they are listened to and well accepted as the people who will bring leadership and development. But the Luo woman politician must also remember her status in marriage and the respect that the society has given her because of her marital status. In her political life she is carrying a husband with her. The difference between my actions and what western women are doing, even when I am an activist within my political life, is that I must remember that a husband exists. I must take care that my activism will not demean or hinder his progress or hinder his status in society or hinder the status of my father-in-law and my mother-in-law in society. Which means that some of the things we are grappling with are inborn. Therefore a Kikuyu woman or a Luo woman may not give a straightforward answer. She will always look back and ask, 'am I carrying the family with me'.

KURIA: Yes.

OGOT: A division that occurs in the mind of an African woman, especially in Kenya, is politics. Those who are going into politics are carrying a very big burden because actually they have broken from the norm. And they have moved forward to an extent that they are now fighting for positions in councils, parliamentary and presidential elections. That is in itself liberation. But there are areas where she knows 'if I go beyond this nobody will vote for me'. I go drinking in bars, if you like, they will not vote for me. I go to night houses they will not vote for me because in African culture you vote a respectable woman leader. The society will allow men to go drinking in this and that place and yet they will still get votes but a woman will not.

KURIA: Do you think that society needs to change so that we can have women who go to such places and also get voted?

OGOT: Well, the problem is that there is fatherhood and there is motherhood. Often times, Luo society in particular, the Luo

society will vote for a married woman. They always give us their votes. When I lost last year, I got nearly seven thousand, it was party. They did not want to vote for Kanu. They wanted to vote for any other party in Luo land. But because I am married and with a family I cannot see a time when I will be going to bars. I see a time when I will be back home so that the mother that the voter voted for would not be the mother going to the bar because the customs are part of me. But if I was single I may not have been voted for in Luo land because you see I also better talk of what I know. As a single girl I will not stand in Asembo, that is where my brother Bob stood. I stand in Gem because that is where I am a mother. I have a cultural right to stand there. What a single girl would have done I do not know. In Luo land, unlike Kikuyu land, she would not be voted. Even if she went to another party. That is not your home and you should be having your home. As far as going to drink in the bars is concerned even the most liberated Kenyan women do not like it. There are structures that would stop her even if she wanted to do it. But *Mzungu* does not have those reservations because going to the bar for them could be part of the society's good. But it is not so among most African women. There are a few rebels...

KURIA: But they are the exception rather than the rule?

OGOT: They are the exception rather than the rule, yes. And that is why even when we go to international communities you will find that African women will say 'no, we will not do that'. And 'no we cannot do that to our men'. It is within the extended family and within the African society. There are some good things among us which are not with them. Why not maintain them?

KURIA: Now, something I would like to know. How do you manage? I ask because I see you wearing too many hats. You are politician, you are a mother, a writer, how do you combine all those responsibilities with your writing?

OGOT: I have not written with my politics. When I went to parliament between '83 and '92, it is very difficult to read in such a

situation. And you have to read everything. You also have to do development programmes countrywide. Being a member of development projects, a few boards, and women's groups and with those kinds of programmes I do not even get time to read the latest books. I am married with grandchildren and I have to take care of each member of the family, only my daughter is not married yet, and help many orphans and many widows. That takes my time from reading. But the final and very important point that I would like to make before we close is that I believe in marriage, very much and I am a great friend of Prof Ogot and I believe in his work and I believe in making a home, a happy home for him, for the many books he is writing, the many Ph.D theses he is working on, working late etc. And also looking at the small family businesses that help us and other people. I am feeling that I might get opportunity to do some writing this year. I am hoping that I will get the opportunity to translate my book, *Sibi Nyaima*, and also finish my book that is three quarter written, *A Call at Midnight*.

KURIA: Most of what you have written, you wrote them after you got married?

OGOT: In fact I wrote more after marriage because Allan told me through my love letters that I was a poet. I said 'no, no, I am not a poet' and that I could not even write a poem. Then he said, 'why don't you try something else' and that is when I wrote about Luo sacrifice. It was through Allan I realised about my writing potential. At the peak of my writing, Allan would keep the children away until I was through with my writing.

KURIA: Thank you very much… You are a very amiable person to talk to.

NOTES

1. The ruling party, Kenya African National Union
2. Hut or house
3. Swahili for 'wander about'
4. Swahili meaning 'this is the man who will net the widow.'
5. Swahili 'even if she refuses'
6. Not doing it secretly
7. mixture of Kiswahili and English suggesting that in other countries polygamy is practiced through continuously divorcing and remarrying
8. it is better for her to be there even if you add another wife
9. This refers to a court case that involved Wambui Otieno, a Kikuyu, and the Umira Kager clan, over where her husband would be buried. More information can be found in Cohen, David Williams and E.S. Atieno Adhiambo. 1992. *Burying S.M.: The politics of knowledge and the sociology of power in Africa.* Portsmouth, N.H.: Heinemann.
10. He or she must spend one night in the Nairobi house and then spend one night in the rural home before burial takes place
11. cooking pot
12. Leave that for the time being
13. Oh she has been kind to me
14. Kikuyu for 'Family secrets are not to be broadcasted'. It is perhaps equivalent to the English saying: Do not wash your dirty linen in public
15. Kiswahi for 'But'
16. And food
17. Kiswahili, You do not have many quarrels
18. Kiswahili 'the teacher finds me in the house with tea ready and to open the door for him'
19. She holds the
20. She puts stumbling blocks in his way
21. Why are you going to buy
22. But/when
23. This is an endearment term used in reference to old men. In this context she was referring to President Moi.

24 He will put in
25 Whiteman/woman
26 Cow
27 expound or explain further

LEAH MUYA

LEAH MUYA

INTRODUCTION

The late Leah Muya was born Leah Wanjiru on 16th August 1938 in Nyeri District. She started her primary education at ACK Irindi in 1946. When her mother passed away in 1953, Leah was forced to stop her schooling in order to take care of her younger siblings for a period of two years. In 1955, she resumed her education and in 1956 she sat and passed her Kenya African Preliminary Examination. Between 1957 and 1958 she taught as an untrained teacher at Rwathia Primary School. In 1959, Leah joined Tumutumu Teachers' College for a two year course and graduated as a trained teacher upon which she was posted to Irindi Primary School. Her marriage to the late Washington Muya wa Karingithi lasted for forty-two years from 1961 to 2002 when she passed away. In her working life, Leah was very versatile moving from teaching to catering in 1972 when she joined Kenya Polytechnic in the Catering Department, to the Inter-Continental Hotel as a Housekeeper in 1975, then to ILRAD in 1977 before finally taking up employment with the Maendeleo ya Wanawake Organization where she served in various capacities for 22 years. Leah was a shining example of what women, with determination, can achieve for themselves, fellow women and society at large. In spite of having had an unfortunate start in life, she managed in later years to study privately and sit for the Cambridge School Certificate examinations, take a course in Catering and Hotel Management, attend a one year diploma course in Sociology in Israel and many other courses. When I interviewed her, she had risen to the level of a Programmes Manager at the Maendeleo Ya Wanawake Organization where she had become instrumental in the emergence and implementation of a programme designed to offer an alternative ritual to female circumcision otherwise known as FGM. During the interview, she came across as a practical, down-to-earth person passionate

about the freedom and equality of the sexes without subordinating cultural roles for both men and women. She believed in home-grown solutions to African problems and I hope her dream will live on beyond her death. This interview was held at the Maendeleo ya Wanawake Headquarters, Nairobi, on the 21st of October, 1998.

KURIA: Let us begin with you telling me what you do in this organisation.

LEAH: My names are Leah Muya and I am a programme officer. I manage a programme that is dealing with eradication of female genital mutilation. The background to this programme is that back in 1981 there was need to do some research to find out the prevalence of the practice and other harmful traditions. We looked at three variables: early marriages, female genital mutilations, and nutritional taboos about which we carried out quantitative research. We selected three districts, the reason being that there was rumour and some information that female circumcision is being practiced in those districts. These are Meru, Kisii and Samburu districts. At that time in the whole country people would not talk about female circumcision because they did not know who was listening and what repercussions it would have on them. When the organisation felt the need to address the issue of female circumcision it was also very difficult for them to actually get support from any area of administration or even private sector, because people do not necessarily talk about their traditions, they live their traditions. Because that is what reflects on their originality, their beliefs and who they are. Their traditional set ups are very important because they dictate what they do and what they will be. Therefore they do not talk about their traditions, and female circumcision is one of the most difficult issues to get people to talk about. That is why we felt that if we were to address the issue of female circumcision we needed to get information from the people themselves. We had, first of all, to get the level of prevalence in those districts.

KURIA: How widely practised did you establish the ritual to be in those districts?

LEAH: It is very widely practiced. In fact the prevalence was over 85% in most districts. In Kisii, Samburu and Narok the prevalence of the tradition was 98% and above. In Meru it was over 76%. Therefore the prevalence was very very high. In spite of that we still did not feel we had enough information to actually carry out an intervention on the practice. So we decided to do a qualitative research where we use FGDs (focuss group discussions) with leaders at local levels, with boys, girls, fathers, mothers and other opinion leaders in the community where we had done the quantitative research. Through the FGDs we were able to get information to answer such questions as who makes the decisions? how are the decisions made? how is the tradition maintained within the communities and actually who triggers it? who discusses it if it is ever discussed and what other elements are involved in supporting the continuation of the practice/tradition? It was very interesting. Earlier we had looked into the issue of nutritional taboos such as in Maasai land, Samburu and Narok where pregnant women are not allowed to eat to their fill. You know, they are denied some types of foods. And even whatever they take is measured to ensure that they do not have too much, you know, to ensure that they will not have problems when they are having babies. We are told that traditionally it was so that the babies would not grow so big as to be unable to come out. But they did not associate other elements such as early marriages where girls are married before they are fully grown, which would mean that the girl is obviously not ready for childbirth. For them they had seen some kinds of problems that had been associated with childbirth, and over a period of time they seem to have been able to look into ways of trying to solve the problem. This is how it is that they denied the mothers some types of food or even to eat enough food. Then we discovered that circumcision is also tied to early marriages because the reasons for early marriages was that the girls had to be circumcised first and then married to people they did not have to make decisions about. So they do not choose their suitors. In preparing the girl for marriage she has to be circumcised. That is what they told us. In our qualitative research we were able to get some of the information and inclination about who, if we were to now start intervening on the issue of female circumcision, would be involved in the programme.

KURIA: To take you back a little bit when you were trying to find out who initiates and who sustains those practices, what did you find out?

LEAH: We found out that almost everybody in the community is involved. The grandmother will want her granddaughter to be circumcised because that is what will make her a total woman. The father is also looking forward to the day the daughter will get a suitor so that he can get dowry, and for him to get full dowry the daughter would have to be initiated through the cut. The mother also will be given an honour, she will be honoured in the community because she has been able to bring up a daughter who is marriageable. So it's the whole set up and everybody is involved. The boys will not even dream of getting involved with or marrying a girl who is not circumcised. Therefore it required getting everybody involved at every stage and for various reasons. The father because of the dowry, the grandmother because she is going to be the centre of interest or the centre of jubilation when the time comes for her granddaughter's marriage. We also found out female circumcision involves a lot of merrying, a lot of jubilation, eating and people did not want to forego that. After we did the research we disseminated the research findings very widely. First of all we disseminated the information to the same people who gave us the information. We told them 'this is your information, we have put it together and this is what you said. It's your information'. At that level they said 'now, what do we do with the information, can you help us do something with it?' and that is how we were able to build on the qualitative research, get the information back to them and that is when they asked us to assist them do something about it. That is how our programme started. In 1984 we started a fully-fledged programme of intervention. We followed on the issue of female circumcision particularly because it had rated very high. But even before we started, the issue of female circumcision was standing very prominently. In the course of the programme, however, we have seen that all other elements of tradition are very important and they make the total component that requires to be addressed. Therefore, in our interventions, we are addressing issues of gender biases and we think it is very important to be addressed

because the reasons why women have been circumcised, as we have been told in our researches as we have talked to people, is because this is going to make women more submissive to men. It will make them look more reliable in that they are not going to get other men. They are not going to be interested in going after other men. Of course the question of acceptability because they are better domesticated if they have been circumcised also comes in here. This has a lot to do with gender roles that the community has dictated that the woman carries out. We also look at the issue of early marriages because it is not just that girls get married after circumcision but that this also means the girls are denied their right to equal opportunities in education. Because of the ritual they are either married off or socialised to feel that they are mature women and hence are unable to reason with their teachers which means most of them drop out of school because of that. We therefore have to look into the issue of education. What are the implications? When the girls get pregnant they will be thrown out of school. This is obvious because the roles of child-bearing and child-rearing are also very important to them and the society. We are also addressing the men because if the boys agree to marry uncircumcised women the ritual will lose its importance since they are the consumers of the goods and how consumers want the goods determines how the goods are tailored. So we are talking to the young people as well. We are talking to the boys and also to the girls so they can know that there are other areas in the country where girls do not get circumcised and they are still accepted in the community.

KURIA: I am told that in different communities they practice different kinds of circumcision such as suna, excision, and infibulation. Is there any one that you found to be more prevalent in any of these communities?

LEAH: All of them were prevalent in various communities. When we go deep and try to find out what parts of the genitalia are taken out, you would find that intentionally they would want to say that they do suna but the effect is excision. In Meru, Narok and Samburu it is excision but the effect of that excision and the process of healing will lead to infibulation. But there are also other people in the

same districts who come from other communities such as the Somali communities who practice infibulation even though they say they do suna. Therefore all differently types are prevailing.

KURIA: Something baffles me here. Take infibulation for example, if anybody had gone through such a thing, especially as I am told that the circumcision was done by women, is that correct?

LEAH: Yes.

KURIA: Did you find any community where circumcision was done by men?

LEAH: No, not in the communities where we carried out the research.

KURIA: So why would people who have gone through such a horrifying experience also do it on their daughters?

LEAH: I did not even mention that one of our findings in our qualitative research was that mothers who had themselves gone through excision said they want their daughters to go through the same kind of operation that they themselves went through. My thinking is that that is all they know. That is the type they know. That is what they have witnessed on the girls or on other women and even their own peers and that is what the circumcisers know. When we asked them a question like, 'would you circumcise your own daughters?', they would answer 'yes', 'what type of circumcision?' they would say 'the same circumcision that I went through'. So I think it is a question of knowledge and experience. My feeling is that the community sanctions are very important. Then I would say that female circumcision has continued in the community because of the socialisation of girls. That from the very initial stages the girl is made to feel inadequate until she has been circumcised. Therefore she is socialised to actually eagerly await that day when she will reach the age of those girls who have undergone the ritual and she will even seek to have it. We also did find out that there are instances where the girl is not even bothered because she knows, the father knows, the mother knows and the whole retinue of the members of her homestead and community know that a time will come

when she will be circumcised, so she does not even ask for it. But there are some areas where girls say 'no I want to go with my peers'. There is also a lot of peer pressure.

KURIA: Oh yes, I did witness it in my village where girls ran away from their mothers, who were opposed to the practice, to their grandmothers' place to have the operation done.

LEAH: There are other areas where the parents have lukewarmly tried to avoid the operation being done on their daughters. But the girls will elope to their aunties, their *cucus*/grandmothers and they will have it. But there are also other instances where the community is kind of looking negatively into the practice, and the parents will arrange for their daughters to visit their relatives where they will have organised for their circumcision. There are all these kinds of dimensions to look at in relation to female circumcision. Therefore in our programme we do not just talk to the parents but we also talk to the community. And the community here refers to parents, leaders, boys in and out of schools and the total community.

KURIA: I found out from the Internet that you have begun interventions in Meru. Do you have interventionist programmes in other communities?

LEAH: Yes, last year we had 90 girls go through the alternative ritual in Kisii and we have other parts of Meru as well, the one you saw is in Tharaka but we have others in the upper side of Nithi. We had 72 girls go through the ritual in August. It is spreading. In Narok, where we have had girls go through the training, one of the aspects that has been cited by communities as very important and beneficial is the giving of family life education to the girls. Education here specifically refers to traditional education for the girls to make them feel that they are still part of the components that make up the community. Education that the community feels that a girl must know. To equip her to become a good girl and to become a good mother. The question of marriageability comes in because people feel that if this girl gets this kind of education, she is ready for marriage. She will become a good daughter-in-law and kind of a

good participant in the community sanctions. And this kind of training also helps the girls feel that they have become mature. This is where we have come up with a programme where we encourage the communities to look into their own traditions and to come up with what goes with the tradition of the coming of age for girls.

KURIA: So let me get that straight. It means that the programme you are running is differently tailored according to each of the communities in question?

LEAH: It goes according to the community. It is community specific if I may say. Actually we do not make the communities do it. We talk to the communities. Of course we use their own information to lead them to come up with the kind of education or programme they want. But it is their own information and a 100% their idea. We only come in to help them put it together so that it will come up the way they want and not start with the last things but start with the first things and end with the last things. This is where we come in. It is a very long process, very tedious but for us it is a very satisfying plan when it comes to fruition or when the reality comes on the table.

KURIA: What you are trying to do is almost to create an alternative culture.

LEAH: It has to be. It is like an alternative culture but it is a culture that sorts out or puts together the assortments of what is done traditionally at various levels and stages and to put it in a package for the community to receive, use and appreciate that they have a product they have always wanted to have without having the girls circumcised.

KURIA: What do they call the programme in Meru?

LEAH: They call it *Ntiranira na mugambo*. It means circumcision by words. This is a translation from the group that started the alternative ritual. They called it themselves *Ntanira na mugambo* which means circumcise by words. That means you talk to the girls. So

you do not cut but you give all the information that pertains to the rites of passage for girls from childhood to adulthood. It has taken some factors like helping the community to believe that cutting does not actually help, educate, or increase anything for the girls. What is important is that training, that education which the girl is given and that is the education required by the community to make her be taken as a woman who has gone through a traditional educational training.

KURIA: I was going to come back to that realisation that we can retain the training without having to go through the practice. Did that come out of your research? That what was important was not so much the ritual but what they learnt?

LEAH: We got an assortment of ideas. We got ideas on what is traditionally done. How do people approach the season of circumcision? What are the things that actually climax the rite of passage for girls? That is the information that we have used to come up with what we would call circumcision through education. You educate your daughter, you give her all that information that the community sanctions as very important for a girl to know but without actually going through circumcision.

KURIA: So are they using different words in the other communities? If the Merus have theirs do the Maasais and the Kisiis have theirs as well?

LEAH: The Maasais talk of circumcise through education and I think it is the same thing. When the Merus say through words it is just a very literal translation and according to their understanding. We have also not wanted to make people to kind of take things from other people and label them as theirs. If they feel they want to take what other people have and they are committed to having them and using them as their own, it is okay. But if some say by words and others say circumcise by education, I think it means more or less the same thing. The intention is the same and it is the intention that is important here. And the other thing that we have seen is that other people also want to borrow the same ideas but the

idea that they are all able to borrow is the idea of getting the girls to go through a rite of passage of a kind sanctioned and tailored by the community without having to go through circumcision or being cut. And I think this meets our desired objective that the girls will not be circumcised.

KURIA: I have read Ngugi wa Thiongo's *The River Between,* you most likely have read it, and in that book he seems to suggest that when Christianity came they argued that female circumcision is something primitive and which should be banned. That approach does not seem to have succeeded. Were you thinking about that failure and trying to rectify it.

LEAH: Yes. I have grown in a community that had those kinds of interventions and I also remember that there were many girls who went through the ritual of circumcision because they thought it was somebody else's intervention. Bearing that in mind, in my own community, I felt that we have to have or take a different approach and the difference that I could think of was to involve the community. The first step to involving the community is to go and talk to the community and this is how we started. This is how we started creating room to let the community tell us about their traditions, why the practice is continuing, who is involved and at what level these decisions are made. We also took the same information back to the people. We thought it was very very important. When we went back to the people they asked us to go back and start reasoning together with them. The point at which they asked us to go back to them, I think, was the breakthrough point. This was a big big challenge because yes they want us to go and reason with them, but how do we reason with them? We used their own words, their thoughts and inclinations so that we could come up with an intervention that is familiar, community based and sanctioned by both the leaders and the led.

KURIA: Now there are campaigners against the practice who are not Africans. Is your approach and theirs different?

LEAH: I think our approach is different because we use the community workers. We use people who live with the community and who

engage in other activities in the community. I think this is very important. People who live within the community, people who are role models in those communities, people who have the language of the people. I think this is where we are different.

KURIA: Are there times when people who are working with you have felt that the approach by westerners is sometimes racist?

LEAH: I think it is also a question of timing. When the missionaries came and started talking about circumcision, like the Anglican church, the PCEA, the AIC and the Methodist churches, those are the four that I remember, they did not start with community. They did not start with everybody. We are now going to the people. Not everyone is a Christian and not everyone is Muslim. Not even everyone is a believer in any of those denominations. So we are talking to everyone. We have no barriers of denominations or religions. But when the missionaries came they were only talking to their own adherents. They were talking to their own flock. I think this is where the difference comes. Why I have said this is because those who belonged to the Anglican or Presbyterian church, for example, if the daughters of their adherents or their members got circumcised the parents were excommunicated from the church. So those were in-house dealings and whatever was happening across the road or across the fence was not their business. They were dealing with themselves. I would say that at that particular time that was their understanding and their approach did not affect the total community. Perhaps this is why the backlash happened. Even the kind of knowledge they had about female circumcision was not enough. They did not know why people circumcised their daughters, they did not know who sanctioned the rituals, they did not know what values circumcision had in people's lives. I do not want to challenge what the missionaries did because for one, broadly speaking, it was something that triggered the struggle against the effect of female circumcision in the concerned communities and in this country particularly. Secondly, I would want to say that since they did not interfere with everybody but rather only those that belonged to their flock, I think they were entitled to do their in house things anyhow they chose.

Kuria: But I think that if they failed we should say they failed.

Leah: This is what I wanted to say, that because of the approach they used, one of condemnation, they could not succeed. They could not even get far. This is why most of the people, even those who went and became adherents, became baptised and members of the church, most of them fell back. They stepped out. They even went to start other churches because they felt that someone else was contravening their domains. That is where the failure came. They came with their own ideas and standards and did not start well with the people so that they could walk with them. I think this is the difference in our approach where we are involving the people. We are involving the victims, the culprits, decision makers and even the circumcisers. We are talking to them so that we can see what role each one of them can play in this programme. It is a big game if I can call it that where the mother is not about to lose, if she were to lose her credibility in the community and in her homestead of course she is not going to let her girl go without being circumcised. Therefore it is good to reason with the mother. Also the girl. If she is not assured that there are boys out there willing to marry her obviously she is threatened. If the father feels threatened because his daughter has not lived up to the expected standards for him to be seen as a *Mzee*, an elder in the community, to be given that *cheo*, that grade of an elder in the community who has succeeded in bringing up daughters that are credible, he is not likely to support the idea. Therefore he needs to go through a systematic plan of being educated and being given an opportunity to say what is required for this girl to mature. And the community at large needs to be assured that the girls are going to bring the benefits that they foresee in having a girl-child born in their community.

Kuria: So here we are talking about changing a world-view?

Leah: Condemning female circumcision will not get us anywhere. That is what I wanted to say. Even saying that it is barbaric will also not take us anywhere. Sometimes I would also think that there is need to be a legislation in parliament against female circumcision but even legislation before people are educated well enough to see what

female circumcision does to the woman and what effect it will have in bringing up a healthy community, what effect it has on the girl during childbirth, consummation of marriage, and long term effects of the cut, actually we will not be going anywhere.

KURIA: I have read a book by an African-American woman called Alice Walker titled *Possessing the Secret of Joy*...

LEAH: I have read it too.

KURIA: In that particular book I notice that the woman who is circumcised is severely traumatised. But when I look at my mother, who went through the practice, she seems to have been very proud of having gone through the practice. In fact if I ever talked back at her she would ask me, how can you talk back to me as if I were not circumcised?

LEAH: She will even wonder why you would choose a wife who is not. But why is she proud? And this is what our research wanted to find out. What is this that makes the women so proud? What is it that makes a whole community proud just because a girl has gone through circumcision? I would say it is because it gives one the ticket to become what the community has always wanted her to be. Secondly, because it brings self-identity for the person in the context of the entire community, which is very important. If we have to approach the practice, therefore, we cannot deny the person her own self-identity. She has to get the total self-identity aspect of it but also get her to make an informed decision against her own circumcision. Or the mother, we must also take her through all the steps aimed at educating her daughter and to getting her daughter to realise that circumcisions does not increase anything to her. This is what the missionaries did not have. They did not have all that time to discuss and get them to participate in all the forums aimed at getting people to understand why the practice should stop. The missionaries also did not have sufficient information. They started by condemning instead of educating and reasoning with people, and also understanding why people do what they do. It is not because they are mean to their children. For example when a mother

in Narok wants her daughter to be circumcised it's because she wants her to be a total woman, the kind of woman the community would want to have. She wants her daughter and herself to get the respect they deserve in their community. The mother wants to get her traditional place of a woman leader in that community and the girl also will be able to receive what is hers, and that is also credible in that she has been brought up that way thus far and she has been given the kind of education tailored to making her a good future mother, a wife and a traditional leader.

KURIA: Now this alternative circumcision that is going on in Meru, for example, when do you get the girls together?

LEAH: Oh this is very interesting because it has reached a point where people are now calling and saying 'I have prepared fifty girls, I have forty girls who need to go through the education'. We organise seminars and workshops, one whole week workshops. It is a long, tedious and sometimes very expensive exercise. It is expensive because girls have to be housed, it's like you are taking girls out there into the stage which we call seclusion. The communities have told us that seclusion is very important because when the girls get circumcised that is the time they get family life education. That time they have been tamed through the cut and as they are going through the healing process then they are talked to. Family life education is instilled into them and they are attuned, just because of that healing process, to be able to sit down and reason and to keep that information in their minds. So when they go out the communities see them as different people. They have gone through the process of the ritual, they have gone through the process of education and so they are now a different category of girls. Therefore what circumcision by words or circumcision by education does is to get the girls into that mood of seclusion and take a systematic approach to instilling that family life education. The family life education is instilled by people selected in the community by the community, people who are credible to the community and people who can carry out that role of giving the girls family life education within their own communities. These people are chosen by the parents of the girls so I am sure there is a lot of work that goes

on even before you bring the girls to the period of seclusion. The girls go through this family life education for at least a total of five days and on the sixth day they come out. It is like they are declared to have graduated through the systematic educational system.

KURIA: And that has now happened in all those communities we have mentioned here?

LEAH: It has happened in Kisii, Meru, Tharaka, Nithi and is bound to happen even in other areas. We are also expecting that we will have some girls in Narok. It has taken time because the process is such that it has to follow the same stances/ steps that it takes traditionally. In Samburu, if I may mention here, circumcision is done on the eve of marriage. The girl is circumcised today and tomorrow morning she walks with her husband. In this case the healing process is different because this girl is going to heal in her mother-in-law's home. If she does not have a mother-in-law too bad or someone else in the community will have to take over. In Narok circumcision is kind of an individual activity where the girl is circumcised in her mother's house. It is a family thing. The people in the community say if a Maasai says 'I am not going to do this' or 'I have changed my mind about this', he has changed his mind and does not want to remember there was such a thing existing. He has erased it in his mind. Since circumcision here is not a community activity, then they do not see why they should sit down and talk about it. This is what we have been wrestling with but we hope that one day the programme will also be established among the Maasai. But we have had had girls who have gone through the institution of education, giving them the family life, and the girls also being declared mature. But the mode of systematising the rite of passage for the girls except for the cutting is different in all the districts.

KURIA: In Kisii, I read an article by a lecturer at the university of Egerton in which he was arguing that the ritual has been transformed, in some parts, from incision and infibulation to merely pricking to shed symbolic blood and that that marks the beginning of the education process. Have you encountered that?

LEAH: It has been cited by some people. We talked to various people and it has been cited but we, as Maendeleo ya Wanawake Organization, we feel that when spilling of blood is involved, whether it is by cutting or pricking, it means that harm is done to the girls. Why should she be pricked anyway. Why should someone get out there to even try to find a place to prick? Why should we inflict any amount of pain on the girl? Again, some will pretend to be pricking but they will cut. You never know. So our alternative, I would not even want to call it an alternative, I would want call it a rite of passage without cutting or pricking, without circumcision or anything of the sort, is the best.

KURIA: Have you been able to assess how acceptable the graduates of your programme are in the community now.

LEAH: Yes. The first group was in August 1996, so it is just over two years now. One of the success stories is that none of those girls who went through that process of alternative ritual has been circumcised. I think that is a mark of success in that none of them changed their mind. And none of the members of the community ever forced them into circumcision. The other one is that we have, in all districts including Samburu and Narok, girls who have refused to be circumcised and they have found suitors and gone on to get married. I think this is a success story. There is one who just got married two months ago. And this girl has gone through a very strenuous time. One, because her father has wanted to marry her off since three years ago. She just finished her form four last year. Her father arranged for her circumcision and early marriage but she refused. When she wanted to get married her father denied her the opportunity to bring the boy friend home to introduce him formally to the family five different times. The sixth time is when the father I think said 'I have had enough of this' and allowed her to bring the boyfriend home.

KURIA: And she has gone through this training?

LEAH: She has gone through the training and now she is happily married. We have two in Samburu that I know of and many in Meru.

Kisiis are also coming up. I think those are success stories and the good thing is that those girls have been married in their local communities in fact within the same villages where people know who has taken her, the son of so and so and so forth.

KURIA: I hope they are not suffering insults and innuendoes as the old times.

LEAH: I do not think so and it has not prevailed. So we indeed are keeping track on what is happening.

KURIA: What is the long-term plan of this programme?

LEAH: The long-term plan for this programme is that it will be self-sustaining. Self-sustaining in that we are training and we will continue training members of these communities to go on handling these cases even after we have left. If the elder sisters have gone through the programme then we expect that their younger sisters will follow suit. We are also building structures for sustainability by educating people who are selected by the community, men and women, boys and girls in and out of school to become peer educators, even leaders from various institutions to become peer educators so that they become responsible for a few houses in their neighbourhood. They become their neighbours' keepers in a way. They will be giving supportive information and these peer educators get a reinforcement or further training whenever we get new information. These are not people who will need to walk far distances but rather just find 'oh so and so has come back from school, what is happening?', and things like this – monitoring on a daily basis so that the girl does not fall back. This means that the parents also have someone to talk to and I think peer education is more community based and in fact family based than other open forums.

KURIA: Why I am asking that is because I am wondering whether in due time there can be an old man or woman known as the educator in the same way some were known as the circumcisers.

LEAH: Yes. Those should emerge from the peer educators because peer educators are better rounded. They can be able to counsel the girls

or the parents at their own pace and in their own time. You know, these things do not come at once. You can have the girls go through the systematic education or circumcision through words, receive family life education but that education needs reinforcement. But in the same traditional set up it is the same mother who calls across the fence looking for or trying to borrow some axe, water or salt or wanting to find out about the market or something else, who is also the educator. As she calls across the fence for these things she is also giving her reinforcement of the same information. That is when she will say 'oh is that so and so? How is she?' And this is how sustainability can come up.

KURIA: Is your programme tailored for off school time?

LEAH: Yes, this is why I am talking of youth in and out of school. Youths-out-of-school training programmes are possible for those that you can sometimes get when the schools are on. The youth have to be in a group in order to go through the systematic education so obviously they have to be together. But for the youth in schools we have what we call some kind of discussion guides where they discuss various elements geared toward getting them to realise what female circumcision does to a woman. We also have schools where we have teachers who have gone through what we call communication for change training and they are giving reinforcements in schools. So we have intervention centres in schools, churches, religious institutions and also community based institutions such as health centres by private people.

KURIA: Earlier on you talked about celebrations, people eating and making merry. I suppose that that also formed one of the elements of making people feel part and parcel of the larger group. In the communities where you carried out research, did they have seasons set aside for circumcision rituals?

LEAH: Yes, there are seasons but I would imagine that these have been moulded differently now because of things like schools. Most of them were set during times of bounty or when food was abundantly available such as after the harvesting period. There is a lot of

food and so they can be able to converge and cater for a bigger group of people. This of course would be the time that the age group would be marked.

KURIA: So are your programmes keeping up with those festivities and things like that?

LEAH: Yes, when the girls go through the period of seclusion and family life education the girls themselves invite their own people on the graduation day. The parents would also come so that the girls can be handed over. Even the circumciser is not necessarily the one that takes care of the girls, so everyone has to come and take what is theirs. Therefore the community, the parents, the brothers, uncles, aunties, cousins and grandmothers all come which means it's a big festivity. They cook, eat, celebrate, dance and all kinds of things. They will say all the same things they say in their own languages and they feel nice. They are relieved.

KURIA: Great. I admire your approach because it does not necessarily alienate the girls from the community. I am an admirer of what you are doing and I hope that this research of mine can also be made public so everyone can see what you are doing. I am very grateful for your time unless you would like to add something that I may have perhaps forgotten to ask you.

LEAH: I just want to add the fact that interventions on a tradition that has been carried out through generations over a period when nobody can remember when it started and who started it, and who actually sanctioned it in the first place, that any intervention that has to be carried out has to start from the community and should be assisted to follow that trend because then if some diversions are put in, the community might follow. It has to be community based, it has to be community sanctioned and it has to be community tailored. Any one from outside would only do justice if they assisted the communities to come up with their own mode of a rite of passage for girls without circumcision.

KURIA: Thank you very much. I am hoping to be able to put all these interviews in a book and hopefully Kenyans will read the material.

LEAH: I hope they will want to read it because it is not one person's information, it is everybody's information and I think that is what we are lacking. We do not document most of what we do. We, for example, do a lot of things but we do not document everything we do and lack of documentation means that we are losing the information that could enrich our communities and the interventions that we do carry out.

MARGARET OGOLA

MARGARET OGOLA

INTRODUCTION

Married to fellow doctor, George Ogola, with whom she has four children, Margaret Ogola is currently Executive Director of Family Life Counselling Association of Kenya. *The River and the Source,* which is her first novel, won the 1995 Jomo Kenyatta prize for literature and the 1995 Commonwealth Writer's Prize for the Africa region's best first book. She has also co-authored a non-fictional text with her husband titled *Educating in Love*. She is a committed Catholic subscribing to the ideas of the sanctity of marriage, motherhood, and the family. In her interview with me she argued that motherhood is empowering, that she does not believe in broken families and that fathers should be the heads of their families. *The River and the Source* is an epic novel spanning generations and tracing the lives of women characters involved in the fight against patriarchal forces without challenging what Ogola considers vital family values. The novel seems to suggest that women can transcend their socially constructed limitations, including ethnicity, and succeed if they worked hard enough. This interview was held at Waumini house, Westlands, Nairobi.

KURIA: You must be a very busy person. It is so hard to catch you.

OGOLA: It is because of late I have had to run this office apart from my regular one. For a period of six months I have been asked to reorganise this one. It is very vital. 30% of the health units in this country are run by the church and there was total chaos waiting. So I came in but by December I should be back to my usual schedules.

KURIA: Is that affecting your writing?

OGOLA: Oh very much. You see writing is a question of time and being able to sit and relax and allow the inspiration to come and sometimes that is not possible. But I have finished a sequel to other one.

KURIA: Oh you have finished another one. Is it published yet?

OGOLA: No. I just finished it a couple of weeks ago. I have already started working on something else but not at the rate at which I worked on *The River and the Source* for example.

KURIA: What is the title of this latest one?

OGOLA: I am calling it *I Swear by Appolo*, which is the first statement of the Hippocratic oath.

KURIA: Are you continuing on the same issues that you raised in *The River and the Source*?

OGOLA: Slightly different but in many ways the same. There are so many things that are the same but I am looking at this again in a deeper way about what a doctor's commitment means in various ways. I am using the same characters because more or less that was really developed in the first one. It takes off from an angle of the other work.

KURIA: Just for the record you are trained in...

OGOLA: I went to Nairobi University both for my undergraduate and postgraduate studies. I studied medicine and paediatrics.

KURIA: And how did you come to be a writer?

OGOLA: Some of these things are instincts. I think I was creating stories in my head when I was growing up as a child out in the village. By the time I was in high school, I wanted to write. If you asked me what I wanted to do at the University of Nairobi, I wanted to write. I did not know how it was done but that is what I wanted to do. But then this country is very heavily science

oriented. And so when I was in form two, I was simply shunted into the science class. There was very little argument that was allowed in those days. So I ended up doing the sciences which meant that I did not perform as well as I would have wanted in literature. I got a credit but I had expected better. So I ended up doing medicine.

KURIA: That is interesting because one of the main emphases in education nowadays is to try and make the girl child to take science because they are otherwise being pushed to the arts. I have seen that kind of an argument. So how is it that in your case you were pushed to the sciences?

OGOLA: In the school that I went to, it was done very simply. They simply divided the classes into two. The upper half did sciences and the lower half did arts and I fell very much in the upper extreme. It was as simple as that.

KURIA: Was that based on overall performance?

OGOLA: I think that it was overall performance. Now that I look back I wonder why they did it because you could have been number one and you got very low marks in one thing or the other, but that is how they did it. The end result was that I have spent a very good number of my years learning medicine. It is very demanding.

KURIA: You said you used to create stories in your mind in the village. What inspired that?

OGOLA: I read a lot. I had the advantage of growing up in the countryside which many city kids lack. There was a lot of farming. I actually grew up on a farm. But there was a lot of time that you were on your own during which you were to create your own interests. There was no television or anything to spend time watching and I think I turned very much to my imagination to create my companions. I was the fifth in a family of six and so my brothers and sisters were more or less in high school when I was still in the middle of primary school and they would bring

all these story books and novels. So I read a lot from a very early age. I was always interested in literary works without knowing what it was that I was interested in.

KURIA: I was wondering whether you also had the chance of hearing oral stories.

OGOLA: My mother told very many stories, short ones with songs. You too know the way African stories go. Since we were translocated, we were living in the middle of Kikuyus, and she felt very strongly about transmitting the culture and traditions, she talked a lot telling us the stories of her life, tribal stories, folklore and with a lot of song. What I enjoyed most were the songs. So that too helped.

KURIA: Would that have also inspired *The River and the Source* because in it you seem to be engaged in the tracing back of the...

OGOLA: The first part, very much and I admit it in the acknowledgements that this is almost verbatim the stories that my mother told me about her origins and how it is that they moved from the village where they were born to the village where she went to school. But after that it also takes off very much on its own because you do want to borrow the stories of people who are alive, they might not take it kindly. But I do find her stories very useful and my mother is a person who is capable of telling her stories in a very graphic way. Up to today. Even pure village gossip will be told in such a way that you really laugh. It was a very interesting way of growing up and definitely I owe her that much. My love for story telling and telling it in such a way that it is as entertaining as possible.

KURIA: What made you write the *River and the Source*, how was it conceived?

OGOLA: I think I wanted to tell the story of women, not women in a universal way, but very particular women that I admired. People have asked, for example, where the figure of Wandia has come from and they think that I am writing about myself

indirectly and it is not, she is a woman I knew and particularly admired in medical school. She probably would know it if she read it. But she is somebody that I admired. I admired the way she worked and carried herself. All the ideas are borrowed from women that I have known and whom I have admired. I wanted to tell the story of women because it is rarely ever told. Women are busy as mothers, keeping houses and with children so they do not have time to tell their own stories. But women are a majority in this country and many women do a great job under very difficult circumstances and raise children who are worthy of being whatever they are. I wanted, in my own way, to tell their stories. But when I attempted to write before, time and lack of experience militated against it. By the time I was doing *The River and the Source* I had just finished my master's degree which in medicine means you have joined the upper classes, medically speaking, so you have more time. When you have your basic degree you are the general person who does everything. People tell you what to do. That is why doctors struggle to do their masters so that they can call the shots a little bit for a change. So I found that between my ward rounds and my consulting work I had time. I wasn't busy medically speaking. I did not have many private patients and my work at Kenyatta Hospital was pretty much under control. So I had time in my hands and I could think once again about things I cared about.

KURIA: Yes

OGOLA: And again at around that time, my father died and my father and I had a very great relationship. He had been sick for seven years and then he died. I am the woman I am because of the man that brought me up. And as he brought me up, my mother was in the countryside. I was in fact living with my father where he worked in Rumuruti. The character of Mark is very similar to my father, better than that of course but this was the man that I had known and admired and really he was an extraordinary man in his own way. Several things happened. The story just fermented. I started writing with my hand because I did not know how to type. I did not even have a computer. I had nothing. I just had pencil and rough paper.

KURIA: The whole book was written by hand?

OGOLA: Yes and very fast. The whole book was written by hand. I then gave it to somebody for typing. She typed it with many errors which I corrected whereupon she typed it again before I sent it to a publisher. I did not know that anybody would be interested at that time because I knew nothing having left the world of literature so long ago. I did not know so much about publishing. But she was thinking and she worked on the book very fast. I am told in record time. The book was written in six months. I have a computer now and it has taken me several years to write the other one. I think it was a story that was waiting to be written and I just happened to sit down and it poured out. I have since then learnt that that was unusual and things do not happen like that.

KURIA: That amazes me because reading it for me it was like reading history dug through strenuous research about generations a long time ago. I was willing to bet that you took time to do some research about it!

OGOLA: Very little. That was a story that was simmering inside me. If any research was done it was something that was very much picked up as I was living my life. I did not have to go and dig out things as you say. No, no, these were things that were just there. As I said, all these things were there and they were waiting for me to come and put them together in some sort of logical order and put a story line through them. It happened very fast. I did not know because I was writing by hand and I had no experience that to write a book using whatever method is unusual. That is something that is a bit of a surprise. *The River and the Source* is very much of a surprise to me. This was not what I was trained to do.

KURIA: Now the other thing is that you grew up in Rumuruti...

OGOLA: I grew up actually partly in Rumuruti and partly in Nyandarua district.

KURIA: Now that is not a predominantly Luo area

OGOLA: In fact there were no other Luos or any other non-Kikuyu tribe for that matter.

KURIA: So how come you have such a graphic understanding of Luo life?

OGOLA: Perhaps it is an accident of birth, the people who brought me up. My father was very modern and he could live anywhere. He is buried among Kikuyus for example. He also was a person who read a lot so that is something I took from him. My mother on the other hand was very strongly traditional. My father would insist that you speak English and Swahili to the best of your ability and my mother would make sure that you also learnt every thing that a Luo woman growing up needed to learn. So everything that I know about Luo history comes from my mum. And because she was a live-at-home mum, she was there doing farm work and house work and all these things, every time that we were there during the holidays she would talk to us. She loved to talk. I think I had a very retentive mind. Anyway she was a very interesting person to listen to and so I learnt a lot. When I come to this town I frequently meet people who have no idea about culture at all who, when they read *The River and the Source*, ask me: 'but where did you learn all this from?' When they hear that I grew up in Nyahururu and went to school there they cannot believe it! But my mother was the sole educator. I left Nyanza province when I was exactly four years old. And I never went to school there again except to visit my grandmothers and for funerals. This meant at most two to three days a week and that is all.

KURIA: I guess your experience then must have made you have a very high regard for the institution of motherhood.

OGOLA: Very much. I think that if I am half the mother that my mother was, then my children will make it. It's not just my mother. When you listen to people talk about their mothers, then you realise that these are the unsung heroines that make

things move. The African woman is too unconscious of her own importance in issues and in creating change yet they do all these amazing things and work incredibly long hours. I was talking to a mother who wakes up at 4.00am and goes to bed at 11.00pm every night so that those children can eat and have some sort of education. Because she does not work in an office she considers herself a non-working person. Because her husband goes to the office at 8.00am and comes back at 5.00pm he is considered a working person. If she is asked she says: *sifanyi kazi*, I do not work. It is this kind of woman whose story I wanted to tell in *The River and the Source*.

KURIA: I am interested in the idea of motherhood. Your novel spans generations of mothers. In the West when they talk about motherhood, the institution of motherhood is seen as something that brings women down. It curtails their ambitions. But it seems to be the opposite in your book. It seems to empower them. Do you feel that way as well?

OGOLA: So much so that I cause a bit of a scandal when I introduce myself and say first of all I am married, I have four children and it is because of these children that I get the inspiration to wake up every day and do what I need to do. I think I would be less than the person I would want to be if I did not have the children and my husband really. My approach to this issue is very African. I think that this is the most important thing in my life: that however many degrees I have, however successful my literary works, if I am a failure as a mother and my children go into the next generation without having achieved the wholesomeness, which you can only achieve from your mother actually, I would feel that I had failed miserably and nothing could replace that. I do not feel that my children have been a drawback in any way. On the contrary they have given me an impulse to go much further than I would have if I had been on my own perhaps with my husband. When I read all these things about the motherhood being a drawback and women needing to be liberated from motherhood so that we can compete with men in the workplace I am a bit sad. When I talk to young people,

you hear them interpreting empowerment as having power over men and I say this country is doomed if the young women who are going to take over from us will consider marriage as some sort of a power game, because it is not. It is very much a question of mutual tolerance and give and take. By the nature of things, women know how to give more than men do. I do not feel that when I give in to my husband for any reason that I am less of a person. In fact I am more of the woman I am because over time, and maybe because of the accident of the man who brought me up, I have come to appreciate fatherhood very greatly. But fathers cannot succeed without the help of mothers. You can be a very good mother without a father but a father cannot really be a good father unless you are giving him support. And this is something that women have lost. There is a lot of competition there. But one must realise that it takes two to form children and that if a child does not see their father as somebody to be loved and emulated, which is something that the mother instils in the child, the child will never know it. You know, the human animal knows the mother automatically but the father could be anybody.

KURIA: You are right.

OGOLA: Then the children are half. They are like birds with only one wing or one strong wing and one weak one which means they cannot fly. They do not go as far as they can and for that reason I am very sad to see the way fathers are very much sidelined from family life these days and women think that they can go it alone. No, they cannot! It may look okay for a while when the children are young but when they reach a certain age you will realise that they could have even been better if the male figure had been around and was allowed and encouraged to be around. This is because fatherhood is not an instinctive thing like motherhood it is very much learned behaviour.

KURIA: That is an interesting one. I have not heard it before but I think it is true.

OGOLA: It is. I think women need to know how important it is and to go all out to give men the room they need in order to create strong families. In short, I am even more a believer in families than I am a believer in women. We need good strong families and the more the families we have brought up by men and women who have some sort of an idea of where they are going the better it is for the whole society.

KURIA: So would you think that in the struggle for women's liberation in Africa, attachment to motherhood would be one of the differences to the western approach?

OGOLA: In fact it is an absolute difference that exists. And I have discussed with other people. I know that an African woman will forego almost everything except the chance to be a mother. Even those women, who do not get partners, they will try to be mothers. They will try to get someone to have a child with. It is something that is peculiar to the African woman. That we feel incomplete without being mothers. Our success cannot be in cars and in big offices and being a powerful executive somewhere. That also but is very much on the sidelines. What makes an African woman feel that I am truly a woman, a self-realised woman is precisely to be a mother. It is not something that I have invented. I think you can ask almost any woman you find here including my young secretary here. A woman in the West will feel, if you do not have a husband or children no problem. Even if you are married and not having children, it is not a big issue. But we are very different in that respect. I think that Africa being a young continent and facing the problems that we are facing, our sense of family is a great strength that I think will carry us far beyond the aids epidemic and all these other problems. I am sad when I see it being eroded away. But it is still pretty strong. I think those of us who have been around know that what we have here is a bit incredible.

KURIA: Yes, only that I am not sure that it is going to be like that forever. It seems like it is being attacked from every side of the divide.

OGOLA: As I have said, I was a bit shocked when I was talking in a group, in fact this was a televised programme, and a young woman said that empowerment is having power over men. She said it and it is on record. People were watching it all over the country. I was very sad that empowerment is not interpreted as giving people opportunities to be the best they can be, be they men or women. I am a mother of both sons and daughters and I would hate to think that my son is being discriminated against. He should not be! He should have the opportunities open to him to try his best. He may fail in some and succeed in others. The same thing applies for my daughters. But I do not see empowerment as a struggle between men and women. Neither do I see men as totally evil nor do I see the predicament that women find themselves in as deliberate evil intent on men's part, neither do I see patriarchy as an invention of men. But I see it very much as a biological necessity for which reasons many feminists would probably cut off my neck. And that is why they fight motherhood. Because you can only understand patriarchy in the context of motherhood. Because a woman who is with child or who is looking after a young one cannot also be out there fending and defending. This is a reality and when I am talking of defending and fending I am also talking about coming to the office to work. There are certain times when it is physically impossible to be in these other places. So if we do away with motherhood then there will be that kind of equality that they want. That is why there is such a bitter fight against 'femininism' understood in the context of motherhood. If we women begin to feel that having children is slavery then they have succeeded. There is no future in that!

KURIA: Interesting.

OGOLA: It is not an accident that almost all over the world there has been a patriarchy. It is because you need fathers and families. And the only stake that men have in family life, and this again is something that women now have either forgotten, do not understand or have been brainwashed about, the only stake that a man has for attaching himself to one woman and her children

is that he be the patriarch. That he be treated with respect and honour in that family because otherwise there is no reason for him to be there. It is so much more fun to be out there. A child is not attached to a man as obviously as it is to a woman. But this again creates balance and is good for society because as they say man alone is a very dangerous animal. I am told by people in the know that 99% of crimes are committed by single men. A good 99%. If you look carefully you will find that most of the men in jail are actually single men. They have no commitment to anybody. It is necessary for men and their understanding of self and their interpretation of themselves as men to be attached to some woman and her children. And that precisely is the reward they get from a relationship. The feeling that I am the patriarch here, I am the father here, you know, what they call the father familia. And we will lose it. The funny thing is that in the long run women will be the losers because we will be obliged to raise these children and do a first class job wherever you are. I do not think that that is to the benefit of anybody. The myth of the superwoman that is being created now is not to our advantage at all.

Kuria: This is becoming very interesting. So what would you say is the role of a woman writing in Kenya and how well would you say the Kenyan women writers are doing it?

Ogola: Perhaps they are not doing it as well as they should. Maybe in doing this work you are going to enlighten young women to appreciate the power of the pen. I always say that I have worked a lot and saved many lives but it is only the power of the pen that has brought me to where I am. Women have a story to be told and they have an angle from which only a woman can tell that story. We appreciate the fact that they are busy, raising families and all that, and for me this is very important and cannot be relegated to second place, but I did not write as a single woman or a woman who had no other work to do. I was writing in between being a mother and between being a doctor. The secret about writing is to present yourself before a writing paper every day for a certain given period of time and the

inspiration will come. It will never come if you do not do that. Because you could have all kinds of inspirations all over the place but you have to have time to sit down for 45 minutes or one hour two or three times a week and put your thoughts together. People think that it is very difficult but in reality it is not. I would encourage women to try it and especially the women with young families who may not want to work full time until the children are older. It is a good thing to explore because the creative world is infinite.

KURIA: There is a lot of stuff?

OGOLA: There is a lot of stuff that you can tell in very many ways. And people are out there. People say that Kenyans are not a reading populace but all things are learnt. May be if we produced more of our own Kenyan stuff instead of relying on our western African friends as if we ourselves have no inspiration or creative ability at all, which is not true, things would be different. Unless we create our own then we will always be slaves of those people.

KURIA: Yes, I have noticed that there is a lot of writing about West and South Africa but very little from East Africa.

OGOLA: I think it is also important to say something about the teaching of English in schools and I think that 8-4-4 has just made it worse. This is the language of international communication and I think that English and Swahili, because Swahili is also a language that I love very much, should be given the rightful amount of time because it is absolutely vital that our children be able to communicate well and confidently. I fear that they are reaching University without being well equipped with the language.

KURIA: And without reading much.

OGOLA: Yes, without a reading habit. That is something that every parent has to inculcate in his or her child: the love of books.

KURIA: I realise that you say you read widely and this seems to have applied also to me. I read books that my brothers brought from high school at an early age. I think the 8-4-4 is not allowing the children that time.

OGOLA: They do not have time. The curriculum is punishing from std one till they leave in fourth form and I do not blame any body for saying never again will I look at a book. That is not right. I think what helped our generation was the fact that we were learning English, mathematics and general knowledge at least up to std seven. The teacher had time to go deeply into the language. We were learning grammar in a way that they have absolutely no idea in the 8-4-4. Maybe when they review this system they will put more emphasis where it is due because there is no point knowing little details about all kinds of things and not being able to communicate intelligently in a chief's *baraza*.

KURIA: While we are still on reading and socialising, would you say that women writers have the responsibility of socialising the girls that as they grow up they should believe in themselves? I am asking this because I have seen the way you trace what I would call the revolutionary spirit flowing from the old lady, Akoko, to the daughters and it continues. Would you feel that it would be nice for the writers to socialise people so that the girls from an early age can believe in themselves?

OGOLA: I think it is vital because our daughters really have nobody that they look up to and yet we have many wonderful people around right here. Believe it or not in spite of everything that we read, there are truly fantastic people that we have in this country. And through the written word you can get to many more people than you can ever meet or you even address on television. It is something that women have to be aware of. That we are the first educators of children. The child begins to learn at the breast how to be a human being, how to smile, how to have confidence in people, how to be a friendly person, how to know that other people are not absolutely bad or good. This is

something that if you leave a child alone in a cot in an orphanage they never learn well. Therefore, to socialise both the girl child and the society at large, I think more could try the literary word to reach as many of these young people as possible so that they have people to look up to. They can then be able to say that it is not impossible for a person like me to get up to where that person is. I, for example, come from a very ordinary background. My father was a very minor civil servant and I know that the very great problem of his life was that of finding school fees and many of my neighbours were like that. Parents made incredible sacrifices. I did not go to some private school in the middle of CBD[1] at a horrendous cost. I went to a village school that I love pointing at because it really made a difference in my life. In spite of that, because of the support that I got from my parents and the friendliness of the teachers, they were very strict but they were very friendly, I suppose because they were not under pressure to do anything that they did not want to do as opposed to now, made me reach where I have reached now. I really would love to see that happen in this day and age. If I had more time I would love to go out and address some of these girls in connection with *The River and the Source* and tell them that it is with you, what you make of yourself is within you, it does not come from anybody else. But in writing I would like to reach as many of them as possible.

KURIA: I do not know whether you know that Evans Mwangi has done a guide on your book

OGOLA: No, I do not know that.

KURIA: I came across it almost by accident in a bookshop, some people were asking for it. I flipped through it and saw that he was suggesting that inside your book is the feminist consciousness. I was wondering would you consider yourself a feminist?

OGOLA: In the sense that I believe in women, yes. But in the sense that I am anti-men no. I believe that women have contributed a lot and could contribute more but I believe that the role of

the male and the female is complementary and that they get further, biologically, I mean these are obvious things also, when they work together in spite of the fact that we are very developed and trying to forget that men and women are simply different. But that does not mean that anybody is inferior to anybody else.

KURIA: Yes, of course difference is not inferiority.

OGOLA: But again equality is a deceptive term because none of us are equal. You are not equal with me and I am not equal with anybody else either among women or among men or amongst my own children. We can talk about equality of opportunity but all human beings are different. What makes us go far as a nation is perhaps the fact that those who are better equipped in any aspect, for one reason or another – because were all gifted in different things – find in themselves the creative ability to lift this nation to where it should be. This is because not all of us have the capacity to do it and yet have the room for the person who is not equal in that sense to also realise himself and contribute to the best of his ability. So this radical equality that they are trying to talk about is not there. It is simply not there in nature. No two people are equal in that sense. But equality of opportunity and respect before the law, all these things I believe in for any human being. But to consider myself as a radical feminist, who believes in the supremacy of the woman, I do not. I do not believe in the supremacy of any human being. I do not think anybody to be supreme over any other, neither our leaders nor anybody else. The sexes are complimentary. My husband is the head of that family, let me put it that way so that it is on record. This is with my help. I think this will make me and my children and himself as well reach where it is that we want to be. If I thought that by virtue of being a doctor like him and a successful writer he should therefore be there to be seen and not heard, we would not attain much. It would simply break my family and I do not believe in broken families. I believe in strong families. I said that the more strong

families there are the better. And women have to be very aware because by nature we have already been given too much. We are mothers and that means power. To be a mother means that you are touching life and forming it and you can form your children for the better or for the worse. Men do not have that capacity as I said. I wish I could say it graphically so that it is clear. Therefore it is easy to sideline men from family life and I think this is not only extremely dangerous but also to nobody's advantage. So while women can immediately identify themselves within their motherhood men have to be brought into family life almost consciously. I am terribly afraid of all these programmes that talk of empowering women. You ask what happens to the men? Where are they? How can you empower a woman and leave a man aside in the same family? What do they mean? Because it isn't women alone who suffer. There are a lot of men who suffer and men perhaps do not have whatever it takes to accept things like unemployment or chronic suffering. Women can bear a lot of suffering over a long period of time. I think it is something that is in the nature because even the girl child from a very early age has a better survival record than the male. There is a certain inability to bear stress and so when you see all these abandoned children and abandoned families you immediately think, oh these terrible men, but it is not the case.

KURIA: Yes

OGOLA: A man comes home today, he has no bread for the family. He comes tomorrow, he has no bread for the family. He looks at these children and these children are looking at him expecting and he has nothing. The third day he simply disappears from the scene because it is unbearable. All these programmes that do not recognise that you need to give men work to strengthen them in order to indirectly strengthen families will never empower women and make children and families stronger. I do not see them doing so by merely giving the women all the education, all the money and you forget the men... You simply are creating a more terrible problem.

KURIA: Keep writing. Many women in this country need to hear what you are saying. And I think men also need to hear what you are saying so that we begin to understand that this is a mutual thing, this is an institution that we build together, not in competition but in co-operation. I have no statistics on this one but I sometimes I wonder whether feminism has contributed to the high number of broken homes.

OGOLA: I can only agree. I also do not have statistics but it is something that you can observe. The divorce rate in the West is absolutely fantastic. I am told in countries like the U.S. every second marriage is expected to end in divorce. However rich a country is I do not think that you can take that sort of set back for granted because it means essentially that many many children are being raised by single parents. And while society can absorb a small number of children raised like that, when it is large numbers of children who do not know what a father is, or who visit their fathers once or twice a week or whatever the arrangements are, I think it is extremely sad. I hope that the great majority of African women, by virtue of their training and understanding in life, will not go in that direction. This is destructive. This kind of competition between the sexes, and the feeling that since I am making more money than you then you have no business being around here, does not augur well for our society. I know that it is creeping in but all I can say is that it is very very destructive and it is something to be terribly afraid of. Again this is something that even governments do not seem to understand. The role of the male as a breadwinner and the reasons why it should be protected. Women, by the way, work out of choice. You have very many other things that you could be doing that could be equally fulfilling. Men have no choice but to work in order to realise themselves. I know that men find it very destructive when they suddenly lose their jobs in a way that it would never occur to me to be if I were to lose this job here in this office. I would not feel that I was a lesser person. But men, their image depends very much on the fact that they are breadwinners and that they are capable of going out to work every day. Unless society recognises this and tries to support it

instead of digging it as they are doing now in the name of all these liberation and what have you, then I can only say that society is bound to lose. This is something that is vital for families. I think I remember a study which has directly linked male unemployment with abandoned children and children without fathers. Simply the inability to be there in the family as a contributing member. It is very hard on men and it is something that we have to look at. While I am saying that women should have the best education possible and the chances, when they want them, to work away from home if they so desire, they need not engage in aggressive competition with men. Work for women is a choice but for men it is something that has to be planned consciously. Even when you are raising children, the boys need more external support than a woman does. And this is a psychological difference. It does not mean anybody is lesser than the other, it is part of the essential differences that exist beetween males and females.

KURIA: There are certain practices in our different ethnic communities that are seen as oppressive practices to women. I have in mind things like wife inheritance, female circumcision, bride price, and things like that. In your book some of them, such as bride price, do not look so much of a hindrance to women's progress and sense of self-worth, but in many works that I have read, written about women's liberation in Africa, those are some of things that they mention as oppressive to African women. What would you think about them in terms of women's liberation?

OGOLA: I think frequently it is a deliberate misrepresentation of an issue and removing it from its historical backgrounds for purposes of the war. All this liberation struggle is a battle, it is a war and there are people who are radically oriented in the same way as the more destructive kind of communism is radical. But when you take things like wife inheritance and female circumcision and all these things out of their historical contexts then you can really deceive people because the purpose, and I am a passionate believer in these things, the purpose of female circumcision

was not to subjugate the woman. It had certain values that were perceived as good. You can reach registration about some cultural practices and do all kinds of things but as long as they are seen to be useful they will be done. In this, it was seen as protective because motherhood is a mystical thing. And that women sometimes died while giving birth to children and from what I have read in many tribes, female circumcision was seen to cleanse a woman so that she could safely undertake the truly great task of being a wife and a mother. And also, there were the rites of passage, the education that went with that, how to be a woman and a mother and I think that people... the unfortunate thing about the African situation is that it is all oral. There is no written history. Some people, remembering the dignified women who were their mothers and the terrible messes that are their daughters, are trying to go back to these things. They think there must have been something in the ceremony itself that helped women to be the kind of women that raised them rather than the kind of women that they are raising who by the time they are sixteen are sexually active, they have a child and have acquired one or two other things. So, that has to be understood in its proper historical background.

Kuria: Yes.

Ogola: I hate the way women will go to international forums and start talking about FGM, we call it FGM medically, as if a part of a lobotomy, a part of the brain was removed. This is a minor operation and in some tribes it is extremely minor. It is just the significance of the shedding or rather the cleansing shedding of blood that was important. But now the women go out there, and many of them have undergone the operation, and they talk as if somebody truly did something terrible to them. But it was something that made you part of a generation, that made you acceptable and feel at home in that generation. They have forgotten that. So when they go and read that western hype they come and bring it here and it is as if men were collecting women and doing FGM on them while it was a women's thing, it was a sister thing, women did it to each other to prepare themselves.

KURIA: That has always baffled me. Most critics always say it was an invention of men and I have never seen any community where men did it. So I keep wondering...

OGOLA: Women felt this thing was good for us. They seem to say so how can we deny our daughters who seem to be in a state of total confusion what seemed to help us so much. There is also the question of wife inheritance. In the African life, as it is, considering male stress in intertribal war and so on; there has always been a severe shortage of males in many of these tribes and that is why polygamy was there. It was usually a very friendly thing. Among the Luo, it was very interesting. I cannot imagine myself doing it now but it was the wife who went to get her sister saying come and help me live and to run the domestic economies successfully. Because child mortality was very high the amount of work that was to be done to make a family successful was quite high. Men tended to be killed in battle or while hunting and all kinds of things so the woman would feel that she would be safe if there was another woman in the home. My mother who is a Christian says that, you know, now that my father is dead, I wish there had been another wife here!

KURIA: Aha!

OGOLA: So it was not seen as oppression at all. It is the same thing with wife inheritance. It has to do with understanding the position of the woman in the home. A woman did move to the home of the husband but she was truly seen as an asset. So when a husband dies, you had two choices. A woman had either to return to her home and look for another husband or begin to look for someone to take care of her sexual needs in a manner that was totally unacceptable among Africans, you know, a date for the evening. This was simply not done. So what do you do next? The brother had to do a duty. It was a duty to his sister-in-law. Of course now many things have come into it and one has to reconsider. I am not saying that one has to stick to one's culture no matter what because things change, but it should not be seen as something that was done to oppress anybody.

On the contrary it was to protect women and children. The idea of a woman with children going out having no husband and being left to the world was something unthinkable. Among the Luo, for example, all my sisters would be considered mothers to my children. The Luo word for auntie is mother. My younger mother. Likewise the Kikuyu have that idea of my younger father, elder father and so on so that no child need ever feel that they had nobody as they are doing now.

KURIA: Yes.

OGOLA: As for bride price maybe there is an element of commercialisation that has crept in now. But traditionally speaking the exchange of gifts was an exchange of gifts and it was not given from one person to the other one. There were things that were given to the aunties, the uncles for having done this or the other because raising children was a communal thing. Likewise to the husband's people, on the man's side so to speak, there were things owed to them because it was truly a contract much better than we are seeing it now and an unbreakable contract amongst many tribes. These kinds of marriage breakdowns that we see is something that is modern. People did not just abandon their marital duties just like that. Since it was something that was so important, a lot of ceremonial exchange of gifts, beer etc, took place. But now you hear a father saying that this daughter of mine has a degree and produces school fees receipts and I think that is the true lack of respect for the dignity of the girl because the child first of all can never thank the parents enough for giving her life and for giving her education. This is something that only a parent can give to a child and a child can only also in turn give to its children. For a parent to give a child life and education and then feel that they have to be paid back is slavery really. That is the one that I am really against. But the traditional concept of dowry and bride price really, when they say bride price it sounds like buying and selling, you know, eased things so that the marriage thing was a continuous thing. It was not that one day you went and came back home with a wife. Before you went for your wife there would have been six months of

negotiations and what have you and all these things were very good. It meant that you knew your in-laws and they knew you and your parents so that you know the kind of people that are taking your daughter and the kinds of people that you are getting involved with. So I think that all I can say is that you have to be very wary of people who take things out of their historical contexts and then put them there on the table as FGM or selling and buying of women or wife inheritance or things like that.

KURIA: Yes

OGOLA: Not to ignore the fact that we have to be amenable to change as life changes

KURIA: That is fine. No one should find fault with that kind of argument. I know many people may not quite agree but I see your point quite clearly.

OGOLA: I know the FGM thing is very emotive but I think it is nonsense. I am sorry but as a doctor and as a woman who is married and therefore sexually experienced I think it is a lot of nonsense and that we are allowing foreigners to take it out of context and to treat us with disrespect because of this. They have their own cultures but because they are from the West we are supposed to fall down and respect what they say automatically. For example, let me say that the whole issue of homosexuality is something that Africans cannot even begin to comprehend, in the West they live with it! So why should they come and dictate to us about FGM and every thing, all these things which they do not even begin to understand. No!

KURIA: I agree with you. I am doing a whole chapter on FGM, because I have read a book called *Possessing the Secret of Joy* by Alice Walker that deals with FGM and I am going to be looking at the issue because I also think that sometimes they just do not understand what the whole thing is all about.

OGOLA: And worse still they take the whole thing and blame it on men while in reality men did male circumcision and women

did female circumcision. And I do not think that women would deliberately do to other women what is bad for them. Definitely not their daughters.

KURIA: It is unbelievable that they would reproduce what they know was bad for them for generations. I think it is undermining their intelligence.

OGOLA: It is and disrespecting our own cultures. We will change it in our own good time, family by family. I am also against this clamouring for registration about things that have got... against thieves and so on yes, but not against culture. People will do their cultures for as long as... and it is not only Africans, you go everywhere else and people have got their thing that they do. We respect them. Let them respect us. And medically speaking women who have had FGM are women to be admired. They are successful as mothers, they are successful as businesswomen, they are successful as women that... the kind of people, so what is all this about FGM and so forth on international forums, in sessional papers, in parliament and so forth. I think it is nonsense. We have serious problems that we should deal with first.

KURIA: Let me turn to the issue of ethnic pluralism. We have already talked about it but let me ask you to comment on how ethnic pluralism in Kenya affects the way you write.

OGOLA: Again I must say that I was very lucky in the sense that I was brought up in pluralistic society. My father was, as I said, a civil servant, an administrator and finally a chief in Rumuruti which had every hue of human being and every tribe, I think six or seven different tribes. Therefore I grew up with other people right from the beginning. I learnt to like them as people or not like them as people on an individual basis. 1992 for me was a bit of a shock. My father has had a piece right in the heart of Kikuyu land. My neighbours, my fathers if I may use the traditional word, are Waweru, the late Kigai and Kamanja and people like that. Those are the men who brought me up because again even though there was that tribal difference and my

mother saw to it that we spoke Luo, Kikuyu was my second language. Years have passed but I can still write my Kikuyu very fluently and when I stand in church to read the Bible people say yes, you have read properly. And it is a very difficult language.

KURIA: Actually when you spoke to me on phone, I said, wait a minute, that Margaret Ogola is supposed to be a Luo but she does not sound Luo.

OGOLA: So I was very much saddened by the so called tribal clashes and this sudden tribal animosity that you feel all over the place and everybody feeling that we need to regroup as a tribe and things like that. We are not going anywhere like that. We had really developed a good national consciousness and saw ourselves as Kenyans going places. I am not saying that tribe even in itself is an absolute evil, really it is part of the extended family, more extended than usual but that was our only security system. We had no other... If I drop dead now the one true security that my children can expect is the extended family. To some degree it still exists. They may not go as far as they would have gone but my children will not starve out there in the streets and I think we Kenyans had reached so far that we have to find our way back to where we had reached and remove ourselves from this political insecurity that has been created by some people. I must say that this has been worsened by the economic situation. When people are poor, they are more suspicious. When people do not have enough to eat... you know Kenyans were dreaming for their children, people were sowing everywhere and watching everything for their children but unfortunately, with what has happened things have changed.

KURIA: Thank you very much for your time.

NOTES

[1] Central business district

PAT NGURUKIE

PAT NGURUKIE

INTRODUCTION

Pat Ngurukie was born Wambui Kirugumi on May 26th, 1948 to the late Jason Kirugumi and late Rakeli Nyambura Kirugumi. Pat's mother was shot dead on the 4th of February 1954 because of her Christian faith. Pat attended Karunaini Primary School between 1956 and 1963 before proceeding to Nakuru Secondary School between 1965 and 1968 where she sat for her Cambridge School Certificate. She then attended Kenya Government Secretarial college between 1969 and 1970. Between 1985 and 1987, Pat privately studied public relations and became a full member of the Public Relations Society of Kenya. She has worked as a secretary in the ministry of Agriculture in Kenya, The Kenya National Chamber of Commerce and Industry, Kenya Shell limited and Church Orr and Associates before setting up her own public relations firm that was eventually wound up due to a declining Kenyan economy.

At present Ngurukie is the manager of Nairobi Pentecostal Church Bookshop which she also helped establish. She began writing in 1976 though her first manuscript has never been published. So far she has four books to her credit: *I Will be Your Substitute* (1984), *Soldier's Wife* (1989), which came second in a writing competition for Commonwealth Countries in 1986 held in Britain, *Businessman's Wife*, which won the Jomo Kenyatta Foundation Award, and *Touch Choices* published by MacMillan Kenya Publishers. A manuscript titled *The Patient*, which was ranked second in a writing competition organized by Evangel Publishers, is yet to be published. She has also translated some Kikuyu fables for which she is yet to find a publisher. In 1990 she was one of seven writers from Africa who were selected to attend an International Writers Programme in the

USA which brought together renowned authors from all over the world. Now separated from her husband, Pat is the proud mother of three daughters. Pat says that she now wants to write novels based on true stories from a Christian perspective. She is also interested in counselling young people and especially women who are going through difficult marriages. This interview was held at Daystar University, Nairobi, on the 14th September 1998.

KURIA: I think we will begin with something that we have already talked about. In our last conversation I remember you telling me that you are concerned that women are at times responsible for family break ups. How would you say that has influenced your writing?

PAT: It may not have influenced my writing positively because usually women will tend to think that it is only husbands that are responsible, but I do know of a few cases where women have been a major contribution to the break up of homes. Because when they find out that their husbands have been unfaithful they also go out and revenge. And that definitely hurts the pride of a man to know that his wife is moving around. And do not forget that in our African context a man is supposed to be polygamous whether you are a Christian or not. They take it that way. So if you really know that and you want to go out there because your husband is doing the same then I can tell you that that marriage will break and it is going to be more difficult to heal that marriage than when it is the man who is actually responsible. This is because the man will actually never forget or forgive his wife. It is difficult. You remember I told you I have talked about it in my book, *Businessman's Wife*. In the story it is the woman who is responsible for breaking up her marriage. She just became a drunkard in spite of her husband being there for her, caring and loving and telling her 'I love you, please do not do that'. She just went ahead...

KURIA: Now that is interesting because when you think about it, especially in the West, when you talk about women's liberation, you are encouraging women to go out and do those things that have traditionally been done by men. Sometimes I wonder whether that is not suggesting that women lose some of their virtues and whether we would, as African peoples, want that to happen. Do you feel that women are being encouraged to lose some otherwise virtuous characteristics that they had before? I think that in most cases women would not be smoking, drinking, engaging in sexual activities outside marriage etc but here comes a movement that tells them to be equal with men, which to some means emulating men in all their virtues and vices. Would you say that is happening?

PAT: It is happening and it is very sad. There are some women who are out to just plunge into so called liberation politics without even knowing what they are getting into. In our African context, and I think it is also Biblical, a man is always the head of the family. Physically, there are ways in which woman cannot be equal to man. It is saddening that just because I have worked hard and I have a doctorate just like you are working toward, that I should feel we are equal in every respect. We are not. We may be equal in terms of our qualifications but spiritually speaking, physically speaking, and I am not saying that just because I am a born again Christian – this is perhaps because of my upbringing – I have never believed that I could be equal to a man simply because of my paper qualifications. I thank God if there is a way that I can get the same job and be paid the same money with you. In an ideal Biblical setting I think there can be a case for you being paid more even if we were doing the same job. Spiritually it goes back to the Bible. You should have more responsibilities than me. You are supposed to be the head of the family. I have my husband and if you look at it that way why would I want me to earn a hundred thousand and Kuria who has a wife and children, who are God given responsibilities, earn the same money? I should feel that though we may have the same qualifications, I have a husband who should be

the one to shoulder financial responsibilities. I am not saying I should not help but I should think that he also deserves, maybe not by virtue of his qualifications but biblically, to earn more. I know that in saying this some people might think, she is not serious. But as for me as me, Mrs Ngurukie, I can step down and say Kuria take this job and let me be your subordinate whether we have the same qualifications or not because to me I know I have more treasure waiting for me elsewhere.

Kuria: I take it that that is also because you subscribe to the idea of the Lord's headship and His being head of the church, and the man through the Lord being appointed the head of the family. Would you say that has influenced the works of art that you have written?

Pat: Yes. Those who have read my works and not seen just another woman writing or just another story there is always that hidden agenda. The hidden agenda that has come out when my books are reviewed in the papers is that I usually talk about families, the forgiveness of others, that no one is an angel, and that the man should be the head of the family. I have tried to bring that out. It may not be so open because in creative writing it may not come out as openly as it would in a textbook. There is always something that the reader is supposed to think. What is she driving at? That is the homework for the reader. Some people who have read my works have contacted and told me personally, or it has come out in reviews of the books, some things that I did not think about. I have read reviews saying 'oh she meant that', and the reading is true.

Kuria: How would you react to the charge that women's liberation activists are inspired by bitterness either because they failed to get married or their marriages failed and that that is why they react angrily against marriage as an institution?

Pat: As I told you in an earlier question some of us are plunging into things we do not know. To answer your question I would never support such women. It is true that for some it is just a

reaction out of bitterness and anger, either it happened to me or to my sister or my friend and I have to do something or talk loud about our need for equality. I think that is a very sad situation. I can tell you now that that will not take women anywhere.

KURIA: You mean if they approach it that way?

PAT: Yes. They can change the approach. If it is a question of qualifications they can approach it like this way: if two young people have both finished Law college, a young man and a young girl, having qualified as lawyers and they are going to go under the same system it seems to me that in this case they should be considered equally. At that time nobody has any responsibilities. The young man has just qualified as a lawyer and so has the girl. If they are going to an institution there should not be any difference in terms of salaries, socially or otherwise. In such cases I can say they should seek equality but in a calm way. Being aggressive is not going to be helpful in any way. It is just going to portray women negatively. And by the way what makes this aggressiveness even sadder is because of what it is teaching our children. When my daughters are reading about me being so aggressive, talking about equality with men and rarararara, the precedent I am setting is very bad because the day she will get married she will never know how to submit to her husband. She will demand equality. And yet what does the Bible say? Wives submit! So when she reads about me in the papers, sometimes I even bring this liberation war home without even being respectful to my husband, never asking if daddy has eaten, are his clothes okay? Has this and that happened? But instead I am busy all over talking about women and their equality, I am setting a bad precedent! Even young men will be afraid to marry our daughters because they will say 'if there is this equality business, who is the head?' We really are destroying our own children. We are destroying our own culture. There are no morals when it comes to that. There is no culture. When you then go back home and begin saying that we Africans have our own culture, what sort of culture are you talking about? Tell me in any African context where a woman was the head?

KURIA: So what would you suggest would be the African Christian approach to women's liberty? Because we must admit that there are some things that are done to women that are not fair. I am thinking of things like dowry where women are seemingly sold. This is surely not fair and I guess there are some things that you would also feel are not fair to women. Would you have a particular African Christian approach to giving women a fair treatment?

PAT: Of course even though I disagree with this liberation of women there are some things that also men should take into consideration in their treatment of women. For example, I should not think that a child should only be associated with the mother when he or she is not successful in his or her education or social life. That is very prominent in our culture. When a girl gets pregnant she becomes the mother's daughter. If the boy does not do well in school or is unruly in society he becomes the mother's son. Yet if the opposite happens, if the girl is doing well the father will proudly say 'my daughter' and the son as well when he is doing well becomes 'my son'. Sometimes it is worse. The father will come and beat his wife if the children are failing. 'Where were you? Look at your son or your daughter'. Why? This is wrong. Whether a child is socially or educationally successful, he or she still belongs to both husband and wife! There should not be such division. The other thing that is very sad is when a man and a woman are equally qualified and the woman cannot be given that job simply because she is a woman. Sex should not be the determining factor. To be honest, and maybe you have witnessed this, there are some women who can do jobs better than men, and sometimes even when the men could be more qualified in terms of education. Yet when it comes to promotion and all that, and I have seen it in the papers and or heard about it, women never get promoted. There are such instances when I agree that women should complain and say 'look, let the man/woman issue of equality be considered here. I am as qualified as this man and we are in the same institution, yet the consideration here is that he is the man'. That definitely makes women feel undervalued. And may be that is what has aggravated them to look for equality but their approach is wrong.

KURIA: Talking about aggressiveness brings me to this idea of feminism. I have noticed that almost all African women writers, most of them at least, have at one time disassociated themselves from it. I suspect you would say the same thing.

PAT: I would say the same thing, very strongly. I am not.

KURIA: But that movement in the West is the one that has been used to campaign for women's liberation. I wonder why African women find it necessary to disavow it.

PAT: I think here Kuria, the two cultures are totally different. May be that is all they know about in the West. They have to be aggressive to get their rights. With us our culture, whether Biblical or otherwise, is different. We are different. Even if you go into the most remote areas where they have not heard of the Bible, the woman is always submissive. So it is something that we inherited, to be humble. I would say with all sincerity that except these days when a few, perhaps because of this wanting to be western, are now shouting loud echoing what their western counterparts are talking about, African women are humble. But do you know something? Maybe deep deep down their hearts these new crop of women are not serious. They are echoing. Yes, they will make all the noises such as they did during the last conference they went to...is it a year ago?

KURIA: Beijing?

PAT: Beijing! They echoed. They talked. But tell me what has been implemented here since they came back? About all the resolutions they came up with, how they are going to fight, what they are going to do, the thing just died a natural death here. Maybe in the West it is continuing. Maybe it is not as fiery as it was but it is continuing. Here I think that it is only within that month they came that we heard of Beijing, Beijing and then the fire died out. Simply because we have a culture. Deep down it is rooted in us that hey, humble yourself, you are still the woman no matter what. Perhaps the West can do that because it is their culture but with us I think it is different.

KURIA: Maybe I am trying to make our culture look nice, but sometimes I think that although it is true that women were not necessarily given very prominent roles and they were not treated very well in our cultures I feel that when that culture was respected in itself it gave women some respect. But those traditions have broken down and because they have broken down that respect that women were given is not there anymore. Is it possible that deep down in our cultures we respected women?

PAT: Yes. And our culture was very rich. I will talk of the culture that I know best, that is the Kikuyu culture. Number one, women were so respected in those early days that during some occasions, such as negotiations over dowry or whatever and meat had to be served, goats and sheep had been slaughtered, women could not eat meat together with the men. People today might call it being humiliated but to me it was good. The men took it upon themselves to serve women. There were particular parts that were strictly reserved for grown up women, others were set aside for young girls and each was served with a lot of respect. The men respected women right from the young age because like the ears, *matu*, they were for the girls. There were some parts of ribs, leg and hand that were supposed to be served to women. And this was done with a lot of respect. The men would call one of the women elders to come and get the meat and share it with the others. The same was done with the young girls. The girls were treated well because if it was an occasion for dowry negotiation the men would argue that those girls would be the brides of tomorrow. Our culture was beautiful. There was no reason for women to feel inferior because the men knew their limits and the women knew their limits. Each one respecting the other, unlike today. I think this why there is this hullabaloo today, 'we want equality, we want this and the other', because men do not respect women and women do not humble themselves. We all want to be equal.

KURIA: Is it that since men do not respect women then women see no reason why they should humble themselves?

PAT: Precisely. In our culture men respected their wives. And the respect was not just directed to biological mothers or wives, no no. A woman as a woman was respected. She was considered worthy of respect and that is why you find that in our culture if a woman, for whatever reason was found misbehaving by any man the age mate of her husband or a young girl the age of her brother, that man had a right to discipline that woman or girl respectively and not necessarily face any opposition. If anything they were told 'well done'. And the same with children. I grew up belonging to a society and not necessarily to my parents, my brothers or my sisters. Discipline from the word go was from the society. If I was found doing wrong, Kuria, believe you me, you had a right to come and beat me up. I would go home with a black eye and say I fell because the minute I said it was Kuria who beat me they would want to know why did Kuria beat me. Of course I had to have done something wrong in which case if I revealed it I might have earned more beating. So whether it was respect for women or the children within society it was there and it was a valuable thing. All that has now fallen apart.

KURIA: Cultures interest me especially in literature. Different communities in Kenya have different practices and those practices mean that women were treated differently in respective traditions. It means that in some communites women are treated badly while in others they are given some respect. I am thinking of things like forced marriages among Maasai. I am sure none of us would want that. I am interested in finding out how those different cultures are affecting women's writing. I notice that you say that some of your works have Kamba phrases, Luo and Kikuyu. Do you consciously think about such things?

PAT: Yes I do. In this book of mine, *Soldier's Wife*, I based it on local names. The local names I have used are from the Kambas. So I had to think, 'how would that man and girl be thinking'. I have therefore come up with some Kikamba phrases which I actually borrowed from a work-mate of mine who was a Mkamba. I could ask him in English 'how would you say this in your language?' and he would write it down for me. In my

other works such as *I Will be Your Substitute*, my very first book, because this girl was a sales girl in a shop she had to meet all sorts of customers and so I bring in this Luo lady and being in Biashara street you pick a few Luo words here and there. I would imagine her saying thank you and good bye. I would imagine this Luo lady having been treated well, she is happy and rather than saying in English 'thank you' or in Kiswahili *'asante saana'*, she just brings out her Luo *'Elo kamano ahinya'*, you know 'thank you very much'. Where the characters are Kikuyus we have Kikuyu phrases. And as you say I have to think what someone would be saying in such and such a situation.

KURIA: What about in terms of transmitting cultural values? Do you think about something like 'the Luo would not mind polygamous families'? Do you ever think about that when you are writing?

PAT: No, not really.

KURIA: It has not come up?

PAT: It has but I try not to do much about it because I may be hurting my targeted readers. I prefer to talk about the culture that I understand best. For example the culture of the Kikuyu people a long time ago was polygamous. That was before Christianity came. You remember that I said our cultures were rich in respecting women? It was really not the man who took a second wife but rather it was the first wife who went out of her way to look for a co-wife. She would spot a girl. At that time physical beauty never featured anywhere at all, although of course – I am sorry to say – no one would go for a cripple or something like that – but physical beauty was totally unknown. It was first and foremost the morals in that girl. Then is she hard working? Is she respectful? Does she respect people? Is she good cultured? Etc. Then the first wife would make friendship with the mother of that girl and on and on things would go. The first wife would get to know the girl even deeper through frequent visits to the girl's the home. And then finally she would

tell her husband, 'by the way I think so and so is not a bad girl. Try to find out'. The man would take that as a green light to go after the girl. Why? Because this is actually the girl the wife wants. That is why I say there was a lot of respect. Even when the man wanted a third wife he consulted his first wife. And by the way they were not just taking those wives to simply have a reputation 'oh he has twenty children or thirty or ten wives'. It was because he had enough wealth to cater for each and everybody. Nobody went without food and other provisions. The number of wives that a man took was actually dictated by the amount of wealth, in terms of cows, goats, sheep and acres of land, he had. In those days remember land was not demarcated. There was no restraint. A man could have a fifty acres piece of land here and another one a hundred miles away as he was able to cultivate. It was through his wealth that he took more wives. And although finally they would sort of congregate together you would find that such a man would have built for each of the women in the homestead where the first wife's house became like a consultation office for every other wife. One of the things that I learnt when I was growing up in the early '50s is that if for any reason the man was not happy with one of his wives, he would consult his first wife. The first wife would be the first one to talk to her before she gets a thorough beating. Disciplining the other wives was not upon the husband. It was the first wife's responsibility. And I can tell you nobody went to gossip about the family outside. That is why the Kikuyu's say, *cia mucii ti como* – Things of the home are not for the public- or as the English people would say, you do not wash your dirty linen in public. So everything was concentrated at the homestead such that nothing went out. It was just there. And the first wife was in control.

KURIA: This is interesting because it brings me to two interesting points regarding the matter of choice. Polygamy is sometimes looked at as if it was something men instituted to oppress women. But you are saying that it is actually women who made the choice to become polygamous. You are saying that it is the

first wife who decided if and when the husband would become polygamous and that consequently her position became an office and an office of authority.

PAT: An office for consultation and power.

KURIA: Very interesting

PAT: And that, as you and I know, was not Christian but by their standards in those years it was okay. And I think that is why there was no sexual immorality. There was no unfaithfulness. That was because the husband had many wives through his first wife. There was no such thing as he came at mid-night. And you know we had another culture, very unchristian but they valued it then. In our culture people then believed that if a disease came the children the man had helped to bring into the world might be swept out and there should have been no remnant to carry the family name. Now what they used to do, and this was accepted in Kikuyu culture, was that the husband would allow an age mate and a friend of his to father a child with his wife. That was not considered adultery. What used to happen, you know they used to have spears, the man coming to father that child would come and put his spear outside the house of his friend's wife. If you, as the husband, came and found the spear – and by the way I do not know how they recognised those spears – you went very far away. And the child so fathered would be loved because if anything happened that child would be the child to carry the name of the family. What I am about to tell you many people do not know. I have a tape like this one which I taped the late Dedan Kimathi's elder sister, I come from the same village with him as I told you. When I taped her, she is called *Nyina wa Nyambura* – and you know me being the child of the village – she asked me '*Wambui, kai utoi Kimathi witu ni mwana wa ucuru*'.[1] And I was like '*Nyina wa Nyambura*,[2] what do you mean *Kimathi ni mwana wa uchuru*?'[3] She laughed and said '*ehe etha*,[4] find out. *Kimathi ndaciaritwo ni Waciuri*.'[5] Waciuri is not the biological father and I have evidence from his elder sister who has since died

because I did that interview in 1976. Kimathi was fathered by someone we know very well *Witagwo Ngaragu*.⁶

KURIA: Who is dead now?

PAT: Who is of course dead now. That was Kimathi's biological father. All I am trying to tell you is how polygamy was viewed in those days. Very unchristian but accepted in the culture of the Kikuyus then.

KURIA: And do you not think that was better then than now because at least the husband would marry and bring the woman home as opposed to now when people are divorcing so that they can marry again? They are still polygamous but they either divorce first or keep secret lovers, in which case they are unofficially polygamous and I think that is more painful to women than the cultural way.

PAT: I agree with you. There is a lot of bitterness because it is no longer the wife who goes out to look for another woman whom she can cope with.

KURIA: She is cheated?

PAT: She is cheated. And our men today are marrying many wives even when they do not have much to offer in terms of material things. If anything that man in fact has nothing. Yet he is keeping a mistress somewhere when his children are being sent away from school because he has not paid their fees. His children dress in tatters even when the man may have a good job because he wastes his money on secret mistresses. He may be driving and living in one of those middle class areas but chooses to go to the slums because, perhaps, he can only afford to rent a house in the cheap areas for a second mistress. That is very sad.

Kuria. I agree with you. I had talked about two matters of choice. The first one was in regard to polygamy. The second one is about Christian women choosing to submit to their husbands out of choice and commitment to Christ and not necessarily

because they are not aware of the women's liberation movement. Is that stance being challenged in this country now?

PAT: It is being challenged very very quietly because if you do not join the movement you are seen to be opposed to its ideals. And yet you have your own Christian morals to uphold. Let me give myself as an example, I would never ever, for anything, change my Christian beliefs to go to a movement while very clearly in the Bible God tells me to submit. Bitter as I might be, frustrated, harassed, stressed as I might be, the Lord tells me to submit. And the Bible tells me 'leave vengeance to God'. If there is anything that the Lord sees being done wrong it is not for me to run and try to force change. No. As far as I, Mrs Ngurukie, I am concerned I cannot run after a wrong that I want to be righted and think that with my own strength and own knowledge I am able to get what I want. That I am going to revenge. I am totally opposed to that kind of approach because I know what my God has told me to do: 'wives submit to your husbands and husbands love your wives'. Let me tell you, if a woman truly truly submits to her husband it is upon the Lord to make the man love her. With all the bitterness that a woman may carry it is not going to bring any love from that man without submission. So what we are doing? *Turahura mai na ndiri*? if you know that phrase.

KURIA: Yes I do.

PAT: We are just chasing after the wind as the book of Ecclesiastics tells us. Doing these things, even this equality and all that hullabaloo, women we are just chasing after the wind. We cannot catch it. Biblically, and from my own experience, we might as well stop chasing this wind and surrender to God. And by the way I wish the women would read the Bible and understand our God. There is nothing that is happening to women or between women and men, even in the secular world, that He does not know or has not allowed to happen. If only they would say 'Lord, we have seen how we have been oppressed, we have tried to bring to the attention of our men this and that and nothing

is working, we now wash our hands. We at least submit to you, the highest authority. Deal with our men'. Do you know that things would change? Prayers would change things. And they, western or African, would no longer need to fight for equality. God would do something and before you know it every man would be treating his wife or any woman with a lot of respect.

KURIA: What you are saying here is that the disharmony now existent between men and women is primarily rooted in disobedience to God.

PAT: Of course. We have disobeyed Him. And what does God say, He hates disobedience. Our women should remember something that our God says. It is in Malachi 2. He hates divorce. He also says that he will surely punish the adulterer. Whatever our men, or women for that matter, are doing and thinking in the name of revenging, some will quote the old Bible and talk about Solomon having very many concubines and many wives and so on, the Lord calls it adultery and He says He will punish the adulterer. Unless they repent God surely means what He says and He says what he means. He will punish them in His time, not your time as the wife. You might wait for what seems to be forever for God to punish your husband but let me tell you that if any man does not repent the wrath of God will be upon him. I wish we as women and wives would learn that and stop chasing the wind of vengeance and equal rights. We should leave it to God to do it on our behalf, and just go by what the Lord is telling us to do. There is a lot of bitterness and even for me to tell you all these is because the Lord has humbled me. I am talking from what has happened in my own life. All this bitterness and wanting to revenge is going to make things worse. And that is why even this equality, they can hold meetings forever if they want, but it will never work. We have been disobedient to God. I know that if I dared say this to women in public I would not know which stone hit me first but it is the truth.

KURIA: Do you think that Christians ought to come out and be bold enough to let the world know that they have chosen to subscribe

certain values not because of ignorance of what else is available but because they have chosen to obey a higher authority than what other human beings would like them to submit to?

PAT: Precisely Kuria. Precisely. That is why I would advise any woman who has been thrown out by her husband to take heart and stop being bitter and leave everything to God. Nothing has happened without His knowledge, and this is especially for Christians who are so much targeted. Why? The devil is here. What is his mission according to the Bible? He comes to steal, kill and destroy. So definitely he is in big business. He has to steal that husband from his wife with a lot of lies. In John 8.44, I think, it says that he is the father of lies, when he speaks he speaks his native language, his mother tongue is lies. He will come and lie to you – 'your wife is old, she is ugly, she has given birth to only daughters, you need sons to inherit you' – and before you know it the man has taken that lie as truth. The devil has stolen him. If you believe the lies you will destroy your family. For the devil it is time to kill. He will kill everything. Even physical, he will kill. He will divide you and your family to conquer so that he can be seen as the one ruling. We as women should understand that if we are Christians and know who our God is, according to the book of Daniel those who know their God will do exploits. If you truly truly know your God do not bother. Do not run after that husband. Let God do it. Just do what the Lord is telling you to do. What? Forgive. Which is very hard until the Lord himself comes in and tells you, 'forgive'. How? Just talk with yourself and say 'Lord, you know me, you know the bitterness in my heart. As a human being I would only kill that man'. Be sincere. Reason with God, 'but Lord, Holy spirit, if you come in me, because I know you are there, help me to forgive my husband. Help me Lord. Take away that human feeling. That physical feeling that I love him as my husband, take it and replace it with your love. As you loved me, the sinner that I am.' We should not just point fingers at our husbands. We are also sinners. The Bible says in the book of Matthew, 'forgive that I may also forgive'. If you do not

forgive that husband of yours that you think has committed that heinous crime, and by the way he has not committed that behind God's back, why should you also be forgiven? Remember God is watching and will surely do what he says he will do. But to help God fulfil his promises organise your life. Forgive that man and live righteously. Do not go revenging moving from one man to another because *ndiri njong'i ona nii*.[8]

KURIA: You mean that that should not be the approach?

PAT: That should not be the approach. Humble yourself and live righteously, confessing all your sins. It does not matter how long it will take but one day, one day the Lord will catch up with that man. If that man will not have repented, do not even want to imagine what God will do. I also advise women that when we pray for our wayward husbands to never ever forget to ask God to have mercy as He deals with them. You see the Lord talks about our words, they are very strong, especially from a woman who knows her God. When you are crying to Him and are praying, not with bitterness but with emotional feeling saying, 'save him for yourself, bring glory to yourself through this wayward husband of mine. He is your child. You have said you will save me and my house for eternity'. When you so groan in prayer, if you forget to ask God, 'have mercy, exercise your utmost mercy when you deal with my husband' you might regret your prayers. The attack might be totally unexpected. Because God is going to hear your groans and as He says, 'leave vengeance to me'. He will really revenge. But if you ask for mercy He will still catch up with him but it will be a lot better. *Wahota gukareherwo kionje nyumba.*[9]

KURIA: *Na niwe wetirie?*[10]

PAT: *Na niwe wetirie*. When our God says He will punish or avenge He definitely will. But on one condition, how is your life with Him. If your life with Him is right the length of time or the modes of vengeance He will use you should leave it to Him. Only ask Him to have mercy.

KURIA: Here is my last one. I do not know whether you are aware of this one. In Meru they have begun something that they are calling circumcision through words. They are trying to make sure that physical circumcision goes but they want to remain with the teachings that used to go with the ritual. It seems to me that their argument is that while the cutting may be wrong the teachings that went with the ritual were not necessarily wrong. Have you heard about it?

PAT: No, you are telling me.

KURIA: I first came across this one on the Internet. I am yet to go and interview some of the women who are involved. But anyway I am sure you are aware of the issue of female circumcision. It has been fought by Christians for a long time yet I read in the newspapers some time ago about this sect called Mungiki whose leaders were saying that they have had about 3000 women voluntarily present themselves for circumcision. Why do you think that should be happening now in this era and age?

PAT: Number one, I must admit I have heard about the group but have not heard about who is involved and what are their objectives and so forth. But out right, my comment is that strange things are happening in this era just as the Lord Jesus Christ himself said they would. Some of Paul's letters in the new testament, regarding the end times, also predict such things. I do not think we have seen much of what we expect to see before Jesus comes. All sorts of things are coming up just to destroy our faith in Christ. I believe that this group is associating itself with a religious sect or something. If you read in the book of Matthew 24 where the Lord Jesus was answering his disciples about the signs of his coming, Jesus prophesied all those things there, about how people would come to mislead and if possible even the elect. I am talking of false prophets, false religions, false people etc. I would not be so much surprised if the name of Jesus would be mentioned there and if not, I believe they are Kikuyus, they are talking about *Ngai wa Kirinyaga*.[11] All these are to do with the prophecies being fulfilled. I would not call

that weird or satanic but I would say prophecies are being fulfilled because Jesus told us to expect them. If this is one of them I just say 'Hallelujah, Jesus you are about to come because this one is part of fulfilling what you said'.

KURIA: Thank you very much. That is all I wanted to ask you today unless there is something that you would have wanted to say that I have not asked.

PAT: No thanks. I think I have talked enough. But perhaps I should just say that I have now moved away from writing novels into Christian children's stories. The reason being that today we are campaigning against corruption and all that, and that it is very good, but we are just removing the cobwebs and leaving the spider if we do not also think about our children. When you remove the cobweb and leave the spider a few days later you will still come and find a cobweb. So can we get down to the root of the problem without pinpointing specific people. The root of the problem Kuria is we the parents. We have moved from our God given responsibility to bring our children up. In the community I grew up in children did not belong to the biological father and mother. They belonged to the community. Discipline-wise that was very important. Today even the biological father or the biological mother does not really bother, does not really care. Whom have we left to discipline our children? Television and rock music.

KURIA: And magazines and newspapers?

PAT: Yes. I think that is why today when a teacher disciplines a pupil the whole village will stone that teacher. When I was growing up in school we used to be thoroughly beaten. But I must say they knew how hard to hit and where to hit! Our bottoms and our hands but never sensitive areas. They would never bang our heads. And by the way those days classrooms were made of mud. You were supposed to get a stick yourself and shape the very same stick that you wanted used to beat you. You might even ask your friend to try it on you. So we could make sure

that stick was smooth. You know, it would not hurt too much if you know what I mean?

KURIA: Yes

PAT: It would be so smooth that by the time you are beaten with it, it would not have *tumiigua*.[12] *Twagathithaga gagatwika*[13] smooth. Unfortunately the kind of teachers we have today their idea of disciplining is actually cruelty to children. I would want to ask them 'is that really the way you would want to beat your own children? Unless you wanted to kill them'. But the point is that the community has completely refused to take its responsibility. The people who can discipline, such as the teachers, are taking advantage and are doing it the wrong way. That is why I thought that though I may never be able to change society and I may never be able to know how many of my books are being read we have to start somewhere. I said let me put my own little contribution so that I will not say I never tried. Let me put some cultural stories together as they were told to us in those days. As I told you, when I was growing up in the 1950s, our grandmothers told us stories as we, the children, waited for food to cook. In school we had vernacular story telling sessions and I feel like I am being reminded that those stories can help because they were based on morals. I am trying to put those stories together. I have done most of them and I am now waiting upon the Lord to provide me with funds to have them published. Then they can be read. We may complain that our children read dirty books and magazines but have we given them an alternative? They will forever read Enid Blyton, and Hardy Boys and whatever because this is the only available thing. That is all they can get in the bookshops, second hand shops, and all those magazines and other wicked publications talking about evil against good. Who has ever come up with a beautiful illustrated book with African stories? I am talking about even children at nursery school level being taught about Jesus through stories. Every thing available today is on violence and violence. They read about violence in the small books in nursery school, the cartoons they watch are all violence. Everything is about

violence. So really how can we blame those kids when they turn against us. They are just being like the rest of us in the society. And who is the society? It is you and I as a parent. We have failed. What our children have inherited from us they will pass on to their children. So let us try and see if at least something can be broken. Let us see if we can, in our little contribution, break the chain. There are at least some in the rural areas that have not been to towns and may not read Enid Blyton or those weird magazines. If they can read those stories it will be some beginning for us. They are the people of tomorrow and they will come to the city when we are gone if Jesus tarries. They will then try to pick up these little things. That is what I am now doing and I am really praying to God that if I can do that and another Kikuyu woman somewhere does a similar thing it can be a step in the right direction.

KURIA. Yes, thank you Pat and wish you all the best.

NOTES

[1] Literally, 'Wambui do you not know that our Kimathi is a porridge child' meaning Kimathi's was not a biological son of his father.
[2] Nyambura's Mum
[3] Was Kimathi really fathered by someone else? Note the phrase would not admit the illegimate child being referred to as a bastard.
[4] You find out
[5] Kimathi was not fathered by Waciuri
[6] Known as Ngaragu
[7] We are just pounding water with pestle and mortar.
[8] I am not ugly either
[9] You might just be brought a cripple into your house.
[10] And you asked for it?
[11] God of Kirinyaga
[12] Little thorns
[13] We used to polish it until it was very smooth.

INDEX

INDEX

A Call at Midnight	95
Aidoo, Ama Ata	25, 60
Asiyo, Phoebe	18, 19, 22, 93
Bride price	141, 144-5
Businessman's Wife	152
Celebrating Women's Resistance	17, 18, 24, 27
Child bearing & rearing	34, 105
Chira	52, 55, 60
Christianity	65, 153, 164-6
Circumcision (see Female circumcision)	
Circumcision by words	108-9, 118, 168
Community sanctions	110, 112, 119
Culture:	
Alternative	108
Traditional	32, 87-8, 145, 155-6, 158
Dangarembga, Tsitsi	9
Dowry	32-3, 144
Education	43, 108, 125, 136
Emecheta, Buchi	25, 60
Equality	138, 155-6
Ethnic pluralism	63-4, 146-7
Excision	105-6
Female circumcision (FGM)	31-2, 41-2, 102-7, 142-5, 168
In Maasai	32, 115
In Narok	103, 106, 114
In Samburu	103, 106, 115, 116
Alternative ritual	43, 101, 107-110, 114-7
Female genital mutilation (see Female circumcision)	
Feminism	25-7, 59, 89-91, 137-8
African	26-7, 34, 91
Western	25, 36, 59, 89, 157
Gachukia, Eddah	20, 25, 42
Gender activism	64
Gender activists	22, 92
Gender equity	20, 22
Gender roles	47, 60-2, 87-9, 140-1, 153-4
Homing In	51, 56, 64
I Cannot Sign	35
Incision	115
Infibulation	105-6, 115

I Swear by Appolo	124
I Will be your Substitute	151, 160
Kabira, Wanjiku	12, 17-47
Kiano, Jane	18, 19
Kikuyu life:	
Kikuyus	63-4, 80, 126, 160
Kikuyu customs	158-9, 161
Local Feminism and Global Perspectives	24
Luo life:	
Luos	30, 52, 61, 72, 77, 79, 85, 129
Luo customs	75, 80, 82-3
Macgoye, Marjorie Oludhe	12, 51-66, 71, 82
Maendeleo ya Wanawake	18, 19, 44, 101, 117
Marriage	30, 59, 82, 86, 105
Mbogo, Jael	18, 93
Moral Issues in Kenya	59
Morrison, Toni	39
Motherhood	36, 39, 92, 129, 133
Murder in Majengo	51, 53, 66
Muya, Leah	12, 101-120
Mwangi, Evans	137
My Co-Wife, My Sister	27, 34
Ngugi wa Thiongo	110
Nguruki, Pat	12, 151-171
Nwapa, Flora	60, 71
Ogola, Margaret	12, 123-147
Ogot, Grace	12, 30, 93
Onyango, Grace	93
Oral stories	72, 126, 170-1
Our Mother's Footsteps	17, 27, 39
Polygamy	28-31, 72-4, 80-1, 160-3
Possessing the Secret of Joy	10, 113, 145
Religions	111
Rites of passage	109, 119
Rituals:	
Traditional	105, 118
Alternative	119
Roots	40
Search of our Mother's Garden	39
Self-identity	113

Sibi Nyaima	78-9, 95
Soldier's Wife	151, 159
So Many Hungers	57
Suna	105-6
Taboos	62
Nutritional	103
The Present Moment	53, 54, 64, 65
The River and the Source	123, 126-8
The Story of Kenya: A Nation in the Making	54, 64
The Strange Bride	78, 84
Victoria	52, 53, 66
Walker, Alice	10, 39, 113, 145
Wife inheritance	77-9, 141, 143-4
Woman power	44, 62
Women leaders	22, 71, 93-4
Women's movement Kenya	22-4
Women's Political Caucus	19, 22, 23